THE ARTS

A Comparative Approach to the Arts of Painting, Sculpture, Architecture, Music and Drama

Thomas A. Walters

University Press of America,® Inc.
Lanham • New York • Oxford

Copyright © 1998, 2000 by
Thomas Walters

University Press of America,® Inc.
4720 Boston Way
Lanham, Maryland 20706

12 Hid's Copse Rd.
Cumnor Hill, Oxford OX2 9JJ

Library of Congress Cataloging-in-Publication Data

Walters, Thomas
The arts : a comparative approach to the arts of painting, sculpture,
architecture, music, and drama / Thomas Walters
p. cm.
Includes bibliographical references.
1. Arts—Comparative method. I. Title.
NX170.W35 1999 700—dc21 99—049086 CIP

ISBN 0-7618-1527-9 (pbk: alk. ppr.)

☺™ The paper used in this publication meets the minimum
requirements of American National Standard for Information
Sciences—Permanence of Paper for Printed Library Materials,
ANSI Z39.48—1984

Table of Contents

Introductory Note

This unique book provides a blend of art history, philosophy of art, and comparative analysis of the arts including painting, sculpture, architecture, music, and drama. This work is not a history of art, nor a book of art education. It is a series of articles written by the author over a period of time and complied. It is offered with the philosophy of the author that one art will help to illuminate the others. Its purpose is for a text to enrich art history, art education, and introduction to the arts' courses at college and university levels.

Introduction

The Opposites: A Vehicle for Style Analysis

The history of mankind has always dealt with polarities or opposites such as static and dynamic, chaos and order, simplicity and complexity. Differing schools of thought have grown up around one or the other viewpoints regarding the opposites. The pre-Socratic philosophers believed in elements that made up the physical universe or <u>physis</u>. Thales of Miletus declared that it was water that was the primary element; Anaximenes thought that it was air, and Heraclitus, fire. Aristotle stated that Empedocles was the one who created the theory of the elements being air, water, fire, and earth. Plato, in his <u>Timaeus</u>, talks about the four elements, and adds number. He mentions Proclus and the fact that he added powers that represented each as follows:

"FIRE
Subtle, acute, moveable

AIR
Subtle, blunt, moveable

WATER
Dense, blunt, moveable

EARTH
Dense, blunt, immovable"[1]

Plato adds numbers, which represent the elements. He says, "Let the number 60 represent fire, and 480 earth; and the mediums between these, viz. 120 and 240, will correspond to air and water. For as 60:120 :: 240:480. But 60 = 3 x 5 x 4; 120 = 3 x 10 x 4; and 480 = 6 x 10 x 8. So that these numbers will correspond to the properties of the elements as follows:

2

FIRE
3 x 5 x 4:
Subtle, acute, moveable

AIR
3 x 10 x 4:
Subtle, blunt, moveable

WATER
6 x 10 x 4:
Dense, blunt, moveable

EARTH
6 x 10 x 8:
Dense, blunt, immovable"[2]

Aristotle understood these elements, but took this theory one step further. In his theory, the true elements were considered to be the four opposing principles of hot, cold, wet and dry from which the four elements of water, earth, air and fire were derived. Aristotle, in his <u>Metaphisics</u>, discusses the Pythagoreans' use of the opposites and says that they related number as being foremost rather than fire, water or earth. He lists ten pairs of opposites attributed to the Phythagoreans:

"Finite - Infinite Resting - Moving
Odd - Even Light - Darkness
Right - Left Good - Bad
Male - Female Square - Rectangular"[3]

Even though they each isolated a different ingredient, they all had one basic presupposition in common and that was that the world was orderly. According to J.A. Philip in his book <u>Pythagoras and Early Pythagoreanism</u>, these early philosophers also had other assumptions in common when he states, "They used two current notions, that opposites reacted to one another, and that like attracted like."[4] The notion that the universe was made of opposites was a common belief. J.A. Philip comments,

> Every thinker wrestled with the problem of opposites and how they functioned. It was obvious that in our universe, as an inherent characteristic of its physis, pairs of contraries were ranged either in balance with

3

one another, or in succession-hot and cold, war and peace, day and night. Our universe being a living one, its life was conceived as characterized by change, but change after an order or pattern in which contrary forces by their interaction produced all the variety of the visible world.[5]

The opposites were thought of as part of the harmony of the spheres that composed the universe. The theme of the opposites has been carried throughout the generations up to our own day. Friedrich Nietzsche, the German philosopher, used the terms Apollonian and Dionysiac to describe the opposites in Greek culture. Apollo symbolized the orderly, rational, and moderate. Dionysius symbolized the disorganized, irrational and emotional.

Georges Seurat conceived a method of painting that he called the "laws of complimentaries" which is a balance of the opposites of color that he describes as "harmony". In a letter dated August 28, 1890 Seurat explains his theory of color opposites:

> Art is Harmony. Harmony is the analogy between Opposites and the analogy between Elements similar in tonal value, color, and line; tonal value, that is, light and shadow; color, that is, red and its complement, green, orange and its complement, blue, yellow and its complement, violet; line, that is, directions from the Horizontal. These diverse harmonies are combined into calm, gay, and sad ones; gaiety in terms of tonal value is a luminous dominant tonality; in terms of color, a warm dominant color; in terms of line, lines ascending (above the Horizontal); calmness in terms of tonal value is an equal amount of dark and light, of warm and cool in terms of color and the Horizontal in terms of line.[6]

He clearly discusses his use of opposites and complementary colors in the creation of his paintings.

Seurat uses a technique called <u>Pointilism</u> in which the paint is applied in small dabs and dots that are varied from one section to another. The eye mixes the color of each separate dot, rather than the artist mixing them on the palate; this is called <u>Divisionism</u>. <u>Divisionism</u>, according to Paul Signac, means "to assure the benefits of luminosity, color and harmony: by the optical mixture of uniquely pure pigments (all the tints of the prism and all their tones); by the separation of various elements (local color, light, and their interactions); by the balancing of these elements and their proportions (according to the laws of contrast, gradation and irridation); by the selection of a brush commensurate with the size of the canvas."[7] Seurat's color theory was worked out almost scientifically, one color would be placed next to its complement so that the eye would blend the colors if one stood at the correct distance. The overall effect of the water in <u>Sunday on the Grand-Jatte</u> is blue; it is painted in pale to mid blues and mid green with the addition of pale pinks and dull yellows. The grass looks as if it is green without any complementary colors added. There are muted yellows and oranges in the lighted areas and violets in the shaded sections. From a distance one perceives that the colors of the painting are uniform and applied in large areas, but when one stands close, it is actually painted in dots of various sizes and colors placed close to one another. The painting is actually variegated in color. There is a balance of the opposites in the use of a complementary color scheme in the painting.

The verticals of the trees and the standing people add a strong chordal element to the work. There is a grouping of trees in the upper right-hand corner that is placed with only a narrow dark strip between each tree. They may possibly be likened to a series of IV chords in a measure of music. The work is also imitative in many respects. The curved shape of the parasols is repeated throughout the work. The curved line is found in the bustles on the

women's dresses and in the hat of the woman seated in the foreground. The work is contrapuntal in the sense that there are very strong vertical lines repeated throughout; however, there is also a balance of horizontals. There is a line that starts at the left and runs along the shadow on the grass. This line is echoed in the line of the extended leg of the man laying on the grass resting on his elbows. The horizontal of the shadow is carried the complete length of the painting and intersects the two seated ladies and finally passes behind the two dominant figures of the man and woman standing together. The contrast of the verticals and horizontals could be considered as visual counterpoint.

Active and stable are certainly two opposites that are present throughout George Seurat's <u>Sunday on the Grand-Jatte</u>. The figures in the painting are very active. They are walking, fishing, bending, running, and sitting. The water is flowing, sailboats are moving on the lake blown by the wind. A little dog, with a ribbon tied around his neck for a collar, is running toward another, larger dog that is stationary. Even though the figures are in action, they appear to be very static and stable due to the rigidity of the forms. They appear to be like paper cut-outs pasted onto the surface of the canvas. Seurat groups his figures into units of two, three, or four, such as the right hand couple, the central mother and child, the two seated figures between them, the man playing the musical instrument, the two people near his feet, the woman fishing, the person kneeling beside her, and the grouping of four figures in the left foreground. These groupings add a compositional balance and stability to the work.

Velazquez, in <u>Las Meninas</u>, shows a little Spanish princess surrounded by her court attendants. On the left-hand side Velazquez himself is at work painting a large canvas. Further back, reflected in a mirror are the King and Queen. Velazquez has captured the expression of the individuals at the exact moment that they are being interrupted by the presence of the King and Queen. He uses light that is reflected off the objects and figures in the

room. He reduces the objects to spots of color with concentrations of lighter and darker tones and highlights and shadows. The individuals are caught in action moving, gesturing, etc., but they are at the same time frozen in place. From a distance the painting looks very uniform and realistic down to the details; however, if one looks closely, Velazquez has used the <u>alla prima</u> method, a spontaneous method in which he dragged a semi-dry brush across the canvas to give the impression of elaborate details. A major theme is the attendants in waiting for the King and Queen; a minor theme is the King and Queen actually painted in the little picture or mirror in the background. The purpose of the mirror is to imply the presence of the King and Queen without making them a major focal point of the picture. If they were in the painting they would have been a major subject.

The four figures in the foreground react to the entrance of the King and Queen in various ways. Light is used to highlight the figures and create the glitter of the satin, velvet, and other materials. The figures are active, yet they are very stable as each individual takes up their own space. They are weighty, as their dresses are bottom heavy. Each figure is contained within an irregular triangular form. All of the figures together form a triangle, and the individual figures form a triangle as well. The background wall is relatively stable compared to the active foreground; however, its composition is made up of rectangular shapes that form a pattern which is very dynamic.

There are at least six levels or layers of action. The dog and the side of the large canvas on the right of the picture are in the foremost plane. There is a grouping of the princess and her attendants in recession in the next plane. Velazquez himself and two other figures occupy the third plane. The wall and the pictures occupy the fourth. The reflection in the mirror of the King and Queen are even further back, and a figure in the open doorway occupies the furthest plane of action. The people in these planes are both active and stable. The solidity of the forms of the indi-

viduals anchor them to the ground, and yet at the same time, their glances and gestures create a rhythm that links each separate individual together in a flowing melody of line and form.

Leonardo Da Vinci's Last Supper was begun in the year 1495 and was finished in the spring of 1498. The correct perspective is maintained by the lines carried through the coffered ceiling, the tapestry on the walls, and the background windows. The grouping of the Apostles serves not only to convey the subject matter of the work, but to create the rhythmic movement of the forms. The Last Supper uses a simple one-point perspective to create the illusion of depth, but it acts as far more than this as it unifies the picture. The lines radiate from a central focal point that is positioned above Christ's head. The picture seems very calm at first glance; however, the series of windows, ceiling, and grid lines create a dynamic rhythm of radiating lines that spread out from a central core similar to the spokes of a wheel.

The table, which runs almost the whole length of the picture, creates a very stabilizing effect. The Apostles are very active, discussing and gesturing, yet they are very stable in form. They form four triangles, with Christ in the center as the fifth triangle. The triangle is one of the simplest, most stable, and at the same time most climactic of all geometric forms. Even though the triads of disciples are grouped in triangular forms, they are linked together by gestures and motions which are wavelike. These wavelike motions move toward the center at which Christ is the climax of the event. There is a stable rhythm created by the lines of the windows and the wall hangings.

Leonardo Da Vinci uses atmospheric perspective in the Last Supper. The items on the table are in focus while the mountains in the background are fuzzy. Photographers use a technique of blurring something in the background and keeping an object in sharp focus in the foreground and refer to this as using "depth of field". Italians call this blurring of an object sfumato. One can liken the use of

sharp-focused images to visual consonance in the work and the hazy areas to dissonance.

The first sketch for Picasso's <u>Guernica</u> was created on Saturday, May 1, 1937, just a number of days after Hitler's attack destroyed the town of Guernica on April 26, 1937. The painting is on canvas and measures 11 ft. 6 in. by 25 ft. 8 in. It is almost monochromatic; it is executed in various shades of grey to bluish and purplish greys and brown greys to black and white. The scene takes place in darkness. There is an open window in the upper right-hand corner which emits light, an arm in the center of the picture plane is holding what appears to be a candle or lighted lamp of some sort, and there is an electric light bulb hanging from the ceiling to the upper left. There are active protagonists in the work—the horse, a bull, and a winged bird. There are four women, one with a dead baby in her arms. A dead warrior holding a broken sword is sprawled in the foreground. The dark background is broken by figures, flames, lamps, sharp angles, and curvilinear shapes. The major theme is one of the suffering of the victims. Picasso portrays this horror through gestures which create a strong tension. The figure on the far right has extended arms, head tilted backward, and mouth open. A minor theme is repose; the hope and escape from distress is symbolized by the light, and the open window represents a way of escape.

The significant expression that Picasso it communicating in this work is one of the abhorrence of evil; the grief, death, and horrors of war. He expresses this through his use of line; the animals and people's mouths are open wide, their heads are turned towards the sky, and their bodies are twisted and contorted. The angular lines and sharp geometrical shapes that overlap help to express this anguish. The tongue of the woman screaming in anguish with a dead baby in her arms, the bull, and the horse are created by triangular shapes that appear to be dagger-like. The shapes of the bodies are very irregular with exaggerated body parts. The hand of the dying warrior is almost the

size of his head, and one of the fingers is the size of his neck. This use of exaggeration, twisted body parts, and knife-like shapes all add to the dissonant effect of the work as a whole. There is also a fragmentation of the parts of the figures in <u>Guernica</u>. The figures do not have all their body parts intact or in the proper locations. This fragmentation could be considered a dissonant element in <u>Guernica</u>. It is this discontinuity of the parts to the whole that conveys the emotions of torment and pain to the viewer.

The chordal nature of the verticality of the trees in Seurat's <u>Sunday on the Grand-Jatte</u>, the major theme of gestures frozen in time, the minor theme of the reflection of the King and Queen in the mirror of the <u>Las Meninas</u>, and the active gestures of the Apostles juxtaposed to the stability of the triangular forms in the <u>Last Supper</u> are all examples of the usefulness of the opposites in under-standing of art works. Eli Segal, in his theory of Aesthetic Realism, outlined in his book <u>Self and World</u>, states, "Aesthetic Realism, in keeping with its name, sees all real-ity, including the reality that is oneself, as the aesthetic oneness of opposites. It is clear that reality is motion and rest at one, change and sameness at once...It happens that music is felt always as a oneness of motion and rest or of difference and sameness. A person, like music, is an aesthetic reality, for every moment of his life he is at once rest and motion, sameness and change."[8] Since the oppo-sites are inherent in the structure of the universe, they are the elements of which art is made. Philosophers may argue concerning the definition of what makes something beautiful. If subjectivity and randomness are accepted as a part of one's epistemology and metaphysics, then this will be reflected in one's ethics and aesthetics, but this does not do away with the fact that there is objectivity and order in the universe. Aesthetics is not a realm divorced from the rest of life. One may argue the relevance of the opposites in a piece of art, but without them we would cer-tainly be at a loss. If everything was smooth and there was no roughness, if everything was grey and there was no

black or white, if there was only dissonance and no consonance, it would be difficult, or maybe even impossible, to discuss the relationships in a work. Without intelligence and rationality, we would not be able to discuss anything. We would be limited to making sounds, gestures, and images to which we would not be able to attach any meaning. The opposites are ultimately useful as a tool for style analysis of art works.

The Opposites used for Style Analysis:
1. Linear and Painterly
2. Plane and Recession
3. Closed and Open Form
4. Multiplicity and Unity
5. Clearness and Unclearness
6. Freedom and Order
7. Sameness and Difference
8. Impersonal and Personal
9. Universal and Particular
10. Logical and Emotional
11. Simplicity and Complexity
12. Continuity and Discontinuity
13. Repose and Energy
14. Heaviness and Lightness
15. Outline and Color
16. Light and Dark
17. Grace and Seriousness
18. Truth and Imagination

1-5: From Heinrich Wölfflin (See notes 9).
6-18: From Eli Siegel (See Notes 10).

The Critical Method

This is a widely used method of criticism which consists of four fundamental steps: 1. Description, 2. Formal Analysis, 3. Interpretation, and 4. Evaluation or Judgement.

STEP ONE: DESCRIPTION
List all descriptive informations:

Title	Media/Materials
Artist	Technique
Date	Location/Site
Provenance	Function
Size/Scale	Subject

STEP TWO: FORMAL ANALYSIS
Analyze the formal elements that compose the work; for example:

Plan	Mood
Line (Melody)	Organization
Color (Timbre)	Tempo
Texture (Harmony)	Rhythm
Perspective/Space	Dynamics
Mass	
Light (Pitch)	
Movement (Degree of activity)	

STEP THREE: INTERPRETATION
Clarify the meaning of the work:

Ideas	*What elements are accentuated?
Meanings	*What elements are negated?
Concepts	*And Why?
Themes	
Symbolism/Iconography	

STEP FOUR: JUDGMENT/EVALUATION
Determine the effectiveness of the work:

Successfulness	Timelessness
Originality	Universality
Significance (Historic)	Subjective Conclusions

Feldman, Edmund B. Varieties of Visual Experience, Ch. 15, The Critical Performance.

Introduction Notes

1. Thomas Taylor, <u>The Works of Plato</u>. Vol. 11 (New York: Garland Publishing, Inc. 1984), 437.
2. Ibid., 438.
3. <u>Aristotle's Metaphisics</u>. Trans. Hippocrates G. Apostle. (Indiana University Press, 1966) (Book A 24) 21.
4. J.A. Philip, <u>Pythagoras and Early Pythagoreanism</u>. (University of Toronto Press, 1966), 45.
5. Ibid., 45.
6. "Seurat to Maurice Beaubourg" August 28, 1890, Published in Rey, <u>La Renaissance du Sentiment Classique</u>, 133.
7. Signac, <u>De Eugene Delacroix</u>, 11.
8. Eli Siegel, <u>Self and World</u> (NY, Terrain Gallery, 1981) 19.
9. Heinrich Wölfflin, <u>Principles of Art History</u> (NY, Dover Publications, Inc., 1950) Table of Contents xi, xii.
10. Eli Siegel, <u>Is Beauty The Making One of Opposites</u>? (NY, Terrain Gallery, 1955)

Chapter 1

Balance and Measure: Ancient Greek Philosophy, Architecture, Sculpture and Drama

The effect of Greek culture on Western Civilization is enormous. Almost everything with which we are familiar such as architecture, literature, philosophy, science, art, music, and drama can trace its roots back to the Greeks. It has been said that if the Greeks had lost the Persian Wars, Western civilization would have been changed dramatically.

The fourth century Greek philosophers are regarded as the backbone of Western philosophy. Socrates spent his life questioning the standards of his fellow Athenians. By doing this, he developed the now famous Socratic method. This method consisted of probing a man's beliefs and showing their inconsistencies. Through this process he reduced the victim to an admission of his own ignorance. As we know, this method is used by today's lawyers in the courtroom. Although Socrates did not record his methods, his philosophy was preserved by his most famous pupil, Plato,

Plato is probably the most widely read of the Greek philosophers. Plato's philosophy is regarded as idealistic and transcendental. In his early dialogues like the Republic and Phaedo, he sketched a view of the entities of the world which are most familiar to the West. These entities or "forms" include the ideas of beauty, truth, and justice. Plato made a contribution to education by establishing the Academy which lasted for almost 1000 years.

Aristotle, a student of Plato at the Academy, contributed to Western Civilization by developing his method

of using concrete evidence in scientific research. His combination of philosophy, logic, and hard evidence has carried through the centuries to scientists such as Charles Darwin, who paid him tribute.

The Western tradition of the theatre has its roots in Greek drama. The tragedy is best known in the works of Aeschylus (<u>Oresteia</u>, <u>Prometheus Bound</u>), Sophocles (<u>Oedipus the King</u>, <u>Antigone</u>), and Euripides (<u>Trojan Women</u>, <u>Bacchae</u>). Comedy and satire show their beginnings in the plays of Aristophanies. These works make fun not only of traditions, public officials, and local customs, they also make fun of the gods themselves. Some of these works include <u>Knights</u>, <u>Clouds</u>, and <u>Frogs</u>.

The development of Greek theatre design led to our modern concept of theatre design. Seating, stages, dressing rooms, and even theatre machinery find their beginnings in Greek theatre.

Greek architecture is probably the most imitated in the world. The use of the "classic orders" is seen in architecture in the twentieth century. An example is Charles Moore's Piazza de Italia in New Orleans. As we know, the Romans followed the styles of Greek architecture such as the Doric and Ionian orders and added a version of their own called the Corinthian. Through the Roman Empire, Greek styles of architecture spread all over the Mediterranean.

We know Greek architecture by such buildings as the Parthenon, the Temple of Apollo, and the great theatre at Epidaurus. The "classic" Greek style in architecture was seen by Thomas Jefferson as "the architecture of democracy", sometimes referred to as the "federal" style. In the United States, the Greek influence is seen in such buildings as the Lincoln Memorial, Jefferson Memorial, and the U.S. Capitol.

Greek drama, sculpture, and architecture are based on the search for the perfect, idealistic form. This form was created by the use of geometry, mathematics, and equal proportion. This "ideal" form is what we generally refer to as "classical form" in Western art. This concept of "classi-

cal form" is especially seen in later Greek sculpture where the forms take idealistic features with emphasis on anatomy, stature, and body position.

An analysis of Greek sculpture and <u>Oedipus the King</u> using the eight lamps of Greek art as outlined by Perry Gardner in his book <u>The Lamps of Greek Art</u> as an analytical tool follows:

1. Humanism
2. Simplicity
3. Balance and Measure
4. Naturalism
5. Idealism
6. Patience
7. Joy
8. Fellowship

I. Greek sculpture

1. Humanism

The principal concern of the Greeks was with human beings, their social relationships and their place in the natural environment. Hellenic man conceived of his gods as perfect beings, immortal and free from physical infirmities, but like man himself, subject to human passions and ambitions.

Perry Gardner discusses the fact that the sculpture of Egypt and Assyria is full of figures of the gods and of worship scenes but these figures are like the human. The gods appear as conventional individuals, and to distinguish them from mortals, the artists used symbolism. They added wings to represent the swiftness of the deity. He says that in early Greek art they imitate earlier art; however, they do not continue, but break away and modify the human type in the direction of the ideal.

Greek youth were trained from childhood for competition in the Pythian, Isthmian, Nemean, and Olympian games. They believed that it was through the perfection of their bodies that men most resembled the gods.

2. Simplicity

Greek art represents each figure in a clear and uncomplicated manner. There is simplicity of line, form and gesture. Gardner, in <u>The Lamps of Greek Art</u>, describes Greek sculpture as having simplicity of form. Notice the simple planes of composition; there is not a great deal of complexity. The texture is smooth. Emphasis is on the universal nature of the statement and not on detail for the sake of detail. Gardner expresses that the Greeks did not strive to do the unusual to call attention to themselves. The sculptor was careful to do nothing that was out of harmony with his surroundings. The idea that he tried to incorporate into his work was not his own idea about the subject, but the character which really belonged to it in the mind of the people.

3. Balance and Measure

Gardner mentions that Greek sculpture has balance, rhythm, symmetry, and proportion. There may not be symmetry in Greek sculpture if the term is used to mean that something is exactly the same on both sides; however if the term <u>symmetria</u> is used to mean a certain balance, centrality and stability, then this is certainly the case with Greek sculpture. There is a rational, logical pose to Greek sculpture, an asymmetrical balance of weight, and an axis that runs down the middle of the figure that is curved, but the volume is balanced on both sides. This balance was not created by the use of mathematics alone, but the human eye was an important factor in determining the proportions and not a rigid module.

4. Naturalism

Greek sculpture was dependent on the careful observation of nature. The artist had opportunities for the study of human bodies that the modern student doesn't have. In the baths and gymnasia the artist could watch the physically fit bodies of athletes in every pose and

action: running, jumping or swimming. Yet, Greek art was not a photographic representation of nature; but a highly idealized one.

5. Idealism

The history of Greek art is the history of a search for the ideal. It is in the idealism of rendering the human body that the Greeks surpassed other civilizations. The Greeks realized that nature is flawed and falls short of the ideal. So, the artist has to improve what one sees, do away with the flaws and come closer to incorporating the perfect idea that lies behind all reality.

6. Patience

Patience is linked with idealism, because if one is going to sculpt the perfect body, then one must have patience as one keeps on refining until the perfect form is achieved. If you have ever tried to carve marble, then you know that it is easy to chip off a section that you want to keep, so you must work slowly and deliberately. It is said that the reason that Leonardo Da Vinci left us with only eight paintings is that his idealism kept him working and re-working his paintings. He was only satisfied with a few of them.

7. Joy

The life of the Greeks was in no means unmixed with both joy and sorrow. The Greek theater, including both comedy and tragedy, is a part of Greek culture that has been handed down to us. However, the Greeks lived according to a norm which included a sense of propriety and harmony. They believed that the person that was happy was moderate in all things. If one went beyond one's limitations, the curses of the gods would come upon one-self and bring unhappiness and eventually death. In sculpture they portrayed youth that were physically perfect and at the height of their joyous years. Even when they portrayed mature individuals, they did not show

every wrinkle in their faces. They were not a people that liked to dwell on the dark side of life.

8. Fellowship

Our day is one of extreme individualism. It is important for artists to express themselves in their work and show their brand of originality. This was not true of the Greek. In Greek sculpture there is a certain uniformity among sculptures of the same periods. This is true because the artist was a member of the polis and was interested in the development of the individual as a part of the whole of society.

II. Oedipus the King

1. Humanism

Aristotle in <u>Poetics</u> states that tragedy is an imitation of an action. The main action in <u>Oedipus the King</u> is the process of self-discovery of Oedipus himself over the course of the play.

The Greeks were interested in the concept of <u>logos</u>. Man's thoughts were important to them as illustrated in Plato's famous parable of the cave. Oedipus is the truthful individual who is willing to suffer for the sake of knowledge. He begins his life in ignorance, but comes to the light of knowledge expressed through various degrees of shading that could be likened to <u>chiaroscuro</u> in painting. It is the ironic fate that he has killed his father and married his mother, revealed to him throughout the play, that is his recognition. This recognition is not limited to one scene, and it is not the usual stereotype of the tragic hero who has a flaw of character because of hubris and then falls as a result. Oedipus has no fault of his own. His fault was that he was born into this world. His fate was decided from the beginning according to the oracle.

2. Simplicity

Oedipus is definitely the central figure of the play; however, great injustice has been done to the analysis of this

work when critics look too closely at the psychology of the individual. For example, Sigmund Freud deduced that humankind in general was cursed with the same malady as Oedipus when he created his Oedipal Complex theory. Sophocles was interested in the ideal man, not the psychological man in the modern sense. Yes, they were interested in man's ideas; however, they were haunted by the fear that the beauty of the whole might be surrendered to the parts. In their reluctance to stress the subtle shades of character, they are different than modern man.

They depicted personalities who were universal types from which practical lessons could be learned. Oedipus is a type from whom one learns the lesson of how important self-knowledge is. This is why the central focus of the play is not his inner torment or psychological anguish.

3. Balance and Measure

The play progresses in an orderly fashion toward a definite dramatic goal, the recognition of Oedipus. Oedipus starts to recognize his identity as the one that killed Laius when his wife recounts the story of his murder. In line 730 Oedipus makes Jocasta restate the incident again, "I thought I heard you say that Laius was killed at a crossroads."[1] This is just one of the many dramatic points in which Oedipus recognizes that he may be the murderer of Laius himself.

There is a series of false recognitions that Sophocles uses to create a tension and to prolong the actual recognition as long as he possibly can. Let's take a look at just one of these internal structures, the "Teriseus scene."

The pace quickens as the plot is revealed and the form alternates between stickomithia and complete episodes. Note the balance between the short revelations of the truth about Oedipus and the long ones. They are in an rRrR relationship or one could call it an aBaB form. It is the internal balance that causes one to sense a unity to the whole.

Other balances could be discussed such as the fact that one sees Oedipus at his highest and lowest psycho-

logical states. This ironic balance continues throughout the play. He chose to blind himself because he could not bear to see the faces of his children and fellow citizens. This action is ironic because all of his life he was blind to his real identity but had physical eyes to see. Now, he finally sees and then blinds himself. He taunted Tireseus who was physically blind, as being blind of insight, but it was Tireseus who was the man of far seeing intelligence.

4. Naturalism

Naturalism, as defined by Gardner, is not the naturalism that looks at the seamy side of life but naturalism in observing nature. Greek tragedy is a mimetic art. Memisis is an imitation of nature or of the action of an individual. The focus is not on the surface details but with the underlying structure of the action in the play as related to the whole. The challenge that Oedipus proposed to Sophocles was that the audience already knew the outcome to the story. They knew he was going to kill his father and marry his mother. Sophocles' task was to postpone the final recognition for as long as possible while allowing the audience to wait for Oedipus to realize his plight. He achieved this remarkably well by causing him to be suspicious of political intrigue, by losing patience with Tireseus, and having his wife spurn the oracle. These events postpone his true recognition by giving him reason to believe that he was innocent. However, after his recognition, he still acts in accordance with his character. He is still the faithful king who saves the city.

5. Idealism

One of the focal points of Greek drama is the fact that it was didactic in nature. Greek drama was used to teach individuals that one does not go against the norm of moderation in all things or else one receives the consequence, death. The characters who went against the norm were examples of what NOT to do.

Jocasta acts contrary to the norm when she denies the reality of the oracle. She declares, "Do not concern yourself about this matter."[2] On page 49 she offers a sacrilegious prayer to escape the prophecy of the gods.

6. Patience

Sophocles does not rush forward to the catastrophe. He reveals the truth in a piecemeal fashion which extends the action and the final recognition all the way to verse 1183; there are only 1503 verses in the entire play. One has to think of this in terms of the Greek audience who already knows the outcome of the play. They know that Oedipus is guilty all along, but they are waiting to find out when he will know. Where Sophocles' great artistic ability shows through is in his ability of postponing the recognition for over three quarters of the entire play.

7. Joy

Sophocles did not like to dwell on the dark side of life, but he did use it to teach a lesson regarding staying within the proscribed boundaries. If one does not stay within these boundaries, then harmful results will surely follow. The Greek norm was ultimately important. In Oedipus, the oracle was given by the gods and was not to be spurned. The joyous part of the play comes at the end of the play when the oracle has been restored and the character of the gods to their rightful position once again.

Another joyful aspect of the play is that Oedipus goes from ignorance to knowledge. This process of enlightenment is joyful, even though he has to flee the city.

The entire polis is saved because of one man's truthfulness. It is important to note that Oedipus does NOT die; however, Jocasta, who has spurned the truth does die.

8. Fellowship

The Greeks were ultimately interested in the relationship of the individual to the whole of society. It does not matter that Oedipus was the innocent victim of the oracle;

the important point is that he saved the city, and it retained its wholeness.

His concern for the city is shown throughout the play. In line 339 he exclaims, "Who would not feel his temper rise at words like these at which you shame our city?"[3] The fact that he was loyal to the polis, even at his own loss by being exiled, is the focus of the play. Oedipus, as a character, was a universal representation of the way that one should live according to the Greek norm even when faced with insurmountable problems. He took the noble action and saved the city.

Chapter 1 Notes

1. Sophocles, <u>Oedipus The King</u>, in The Complete Greek Tragedies ed. David Greene and Richmond Lattimore. (Chicago: University of Chicago Press, 1954) 42.
2. Ibid., 41, 49.
3. Ibid., 24.

Chapter 2

Amiens Cathedral: The Summa of French High Gothic Architecture

What is the subject matter of Amiens Cathedral? The subject matter is more than just a mere realistic description of the building. It is more than just the "style" of the structure. The subject matter is a trace of the significant ideas that created the Gothic Cathedral. The subject matter has to do with the reason for its existence. One of the significant notions of the Medieval cathedral builder was that the building was the visible, physical manifestation of the concept of perfection. The Gothic cathedral was designed to produce in the worshipper a concept of what heaven was going to be like. The concept of a building being the embodiment of the medieval ideas of perfection may seem like a very mystical idea, but in fact it was very concrete to the medieval mind.

The notion of ethos was inherited from the Greeks and accepted by the medieval philosophers and theologians. Ethos was a concept that was related to music in the writings of Plato and Aristotle. Ethos was a doctrine that powerful effects of the mind, body, and soul for good or evil could be generated by the music according to what notes were played. Some music was considered appropriate for women and children to hear and other notes aroused the passions and was not considered fit for them. The Pathagoreans created a numerical system based on musical ratios. The instrument that demonstrated the ratios of 2:1, 3:2, and 4:3 was called a monocord. The monocord was a hollowed out wooden instrument with a sound hole

and one string. During the Middle Ages the intervals of unison, the 4th, 5th, and octave were considered perfect intervals, and thus these notes played together in a melody sounded good to the ear and were considered consonant while everything else was to a lesser degree consonant or dissonant. The augmented 4th note was a tritone and considered the Devil in music. Now one asks, how does this relate to architecture?

The Medieval Cathedral was not just built at random, using any proportional system that looked good to the eye, but was built on a highly complex system of symbolism related to the mathematical relationships of spaces and volumes. The perfect ratios were applied to the proportions of the structure, and the unity of the whole to the parts was also taken into consideration because the ratios, proportions, volumes, and spaces would create a predetermined religious or meditative mood.

Looking at the exterior of the Gothic Cathedral from a distance, one knows that it is an important structure just because of its monumentality. The Cathedral dominated the Medieval landscape unlike today in which the skyscraper holds prominence. The Church, which was a symbol of heaven, was meant to be of central significance and a reminder of not only heaven but also of the consequences of evil. The Gothic Cathedral was built as a gift from humankind to God. The word Cathedral, derived from the Latin cathedra signifies that the bishop's seat is within.

The Gothic Cathedral was designed to give the worshipper an aesthetic foretaste of heaven. The entrances were considered the gates to the New Jerusalem. Since the cathedral was considered as the heavenly city, the higher the ceilings could be raised, the more an illusion of heavenly space could be created. Some of the aspects that separated the early Gothic style from the later High Gothic were that the height of the vaulted ceilings were higher, the aisles were expanded, and the bays made wider.

The cathedral at Amiens is considered by some to be the summa or culmination of the French High Gothic

style. We will compare Amiens with Sens Cathedral, considered the first Gothic Cathedral, so that the characteristics of High Gothic will be more clearly understood.

Sens Cathedral was the first building of its size to be covered with a cross-ribbed vault. The nave is fifteen meters from column to column. The height of the ceiling at the point where the vault ribs meet their keystones is eighty feet above the floor level. Sexpartite vaulting regulates the alternate arrangements of clustered piers and cylindrical columns which are doubled. The vaulting shafts of the main transverse and diagonal groups of ribs are carried down to the floor.

At Sens there is a tripartite facade composed of nave, arcade, triforium, and clerestory which reflects the notion of medieval number symbolism. The number three represented the trinity or Godhead: Father, Son, and Holy Spirit.

The Gothic skeleton is apparent for the first time at Sens, but the original fenestration program was composed of very small windows that were enlarged in the thirteenth century so that the building that one sees now does not produce the same visual effect. More light is allowed to flow through the structure than with the original smaller panes of glass. The smaller windows, in not allowing as much light to penetrate the facade, would not let in as much divine presence according to the medieval theory of Divine Light.

The square bays of the nave and choir are divided into two by the middle rib of the sexpartite vault. Thus they are twice the width of the bays in the aisles providing a ratio of 1:2. Otto von Simson has stated, "It is possible to give the same proportion to the relative heights of the nave and the aisles. The elevation of the nave to the springing of the vaults, however is subdivided at the level of the arcade imposts into two equal parts: the octave ratio 1:2 permeates the whole edifice."[1] Numeric symbolism permeates the whole structure, this being one example of how the Medieval cathedral builders incorporated the symbolic meaning of perfection into their architecture.

A labyrinth in the floor at Amiens, which was destroyed and now replaced with a copy, had an inscription which dated the beginning of the church at 1220. Robert de Luzarches was the master architect that was responsible for the nave. In contrast to the usual practice of constructing the choir and then the nave, Amiens was built from west to east. When funds ran short the project was suspended until 1269 which is the date that appears in the glass of the apse clerestory.[2]

The first visual impact of Amiens is created by its immense size. The vaults of the ceiling rise to a height of one hundred and thirty nine feet. Every part of Amiens is proportioned to the whole of the structure. Sometimes the regard for proportion involves, because of the great verticality of the structure, the subtle use of optical illusion. The triforium is actually out of proportion with the nave and clearstory; the arches are tall and attenuated and the capitals of the columns are elongated, but from the ground level everything looks to one's eye to be in proper proportion.[3] The medieval builders, during the High Gothic period, were concerned with the visual perception, of how the building appeared to be in perfect visual harmony just as the walls of the New Jerusalem, were to be the perfect height and width.

Ribbed vaulting was important to the construction of Amiens; however, the form of the ribbed vaulting changed from previous vaulting. Prior to the year 1200, vaults sprang from a solid wall at a point below the base of the clerestory. These vaults were usually of sexpartite configuration and there were only a few exceptions. In the High Gothic churches (after 1200) there was a shift to quadripartite vaults springing from a point above the base of the clerestory. The disadvantages of the earlier sexpartite vaulting was that the vaults springing from below the clerestory partially blocked the streams of light coming from the windows. Sexpartite vaulting also limited the height of the clerestory walls. Since the goal of the Gothic builder was to build higher and higher walls in order to

reach closer to heaven, a new system of vaulting was necessary. The quadripartite vaults springing from a point above the base of the clerestory allowed a dramatic increase in the height of the clerestory and allowed more precious heavenly light into the interior of the cathedral.

The masters of Amiens took advantage of the quadripartite design and raised the heights of the vaulting to higher limits than previously thought possible. At Reims the height of the clerestory windows is more than thirty feet, and the vaults spring from a point twelve feet above the base of the clerestory. The clerestory wall at Amiens attained the height of fifty feet. The vault springing is more than nineteen feet above the base of the clerestory, seven feet higher than Reims.[4]

Amiens was created using a cruciform plan. The plan further indicates the quadripartite, ribbed, vaulting system delineated by transverse arches which spring from a compound pier. There is a semi-dome over the apse with quadripartite vaulting in the ambulatory and quinpartite vaulting in the apsidal chapels.

The facade of the cathedral is dominated by two towers which replicates the tripartite division of the central basilica. The buttresses run down the facade to the level of the portals, dividing it into the equivalent of three aisles of the nave. The portals are formed of pointed arches and crowned with gables of two different heights. Above the arches, the central section is filled with the great rose window.

The circular form of the rose window, because it has no beginning or end, symbolized eternal life to the medieval mind. Other meanings included the notion of perfection and unity of the earthly and heavenly spheres.

Although the west window formed a part of the thirteenth century design, the tracery was renewed in the flamboyant period. Flamboyant architecture derives its name from the flame-like tracery around the fenestration. Architecture became a decorative art in this period. The change is evidenced by the arches. The ogee arch replaces the round or pointed arch of earlier periods. The

stonework around the windows becomes a lacework of delicate patterns.

In earlier Gothic architecture, the architect would place a gable above a porch because it served a functional and structural purpose—to keep the sculpture from injury from inclement weather. When, as at Amiens, this gable is pierced by a trefoil opening and is also transferred to the interior over the choir stalls, it is evident that it doesn't serve a structural purpose, but a decorative one.

Around the rose window one notices a half wheel around which seventeen small figures are placed. Eight of them seem to rise with the wheel as it turns and eight descend with it. At the top, a seated man with a crown on his head and a scepter in his hand, remains still while everything around him is in movement. Boethius mentions the wheel of fortune in his <u>Consolation of Philosophy</u> when he states, "I make a wheel turn rapidly; I love to raise what is down, and lower what is up. So, mount if you will, but on the condition that you will not be indigent to fall when the laws of my game demand it."[5] The Middle Ages, which took everything literally and loved to clothe abstract ideas in concrete form, gave artistic reality to Boethius' metaphor.

From the twelfth to the fifteenth century, whenever rapid changes of fortune were to be recalled, this was represented by the symbolic wheel on which mankind rose and fell. Thus, the wheel of fortune at Amiens provided another subject for the meditation of Christians: royalty which confers riches, glory and power lasts only a short time. The king, whom we envy, is seated on the wheel; tomorrow another king will replace him. Our work of learning, all of our efforts, must not be directed toward the possession of earthly riches. We must "seek first the kingdom of God" to have a solid foundation.

The sculptural relief program at Amiens includes a representation of the twelve virtues and the twelve vices. The three theological virtues of faith, hope, and charity are combined with two of the cardinal virtues, fortitude and

prudence, along with other virtues and vices to make up an alternating pattern of opposites including: faith and idolatry, hope and despair, charity and avarice, chastity and lust, prudence and folly, humility and pride, fortitude and cowardice, patience and wrath, gentleness and harshness concord and discord, obedience and rebellion, and perseverance and inconstancy. These, along with other themes relating to the Virgin Mary, the visions of Ezekiel and Zechariah, the prophecy of Zephaniah and the story of the Magi, are carved in quatrefoil design. On the west facade are carved sculptures of the apostles with six on each side of Christ.

The Gothic ideal was to create the impression that the cathedral rose into the heavens. This was achieved through the verticality of the structure. Amiens, at the height of High Gothic, because of its verticality, gave the sense of soaring space. The sense of visible support and solidity of the upper nave walls disappears. The walls appear to look almost paper thin compared to the thickness and mass of Sens and the earlier Gothic style. The early Gothic style did not allow for as much light to penetrate the buildings because of the sexpartite vaulting system. The height of the clerestory and the larger High Gothic windows allowed more light to pass into the churches thus allowing the divine light from heaven to stream in as never before and allow the congregation to approach closer to God.

Chapter 2 Notes

1. Otto Von Simpson, <u>The Gothic Cathedral</u> (Princeton University Press, 1956) 144.
2. Helen Henderson, <u>Cathedral of France</u> (1929) 26.
3. Ian Dunlop, <u>The Cathedral Crusade</u> 167.
4. William Taylor and Robert Mark, "The Technology of Transition: Separtite to Quadripartite Vaulting in High Gothic Architecture," <u>The Art Bulletin</u> December 1982: 580.
5. Emile Male, <u>Religious Art in France: The Thirteenth Century</u> (Princeton University Press, 1984) 96.

Bibliography

Aubert, M. Mariel. L'Architecture Religieuse En France A L'Epoque Gothique. Paris: Auguste Picard, 1926.

Browne, Edith A. Gothic Architecture. London: Adam & Charles Black, 1911.

Bumpus, T. Francis. The Cathedrals of France. New York: Fredrick A. Stokes Co.

Cranage, D.H.S. Cathedrals and How They Were Built. Cambridge: Cambridge University Press, 1951.

Crom, Ralph Adams. The Substance of Gothic. Boston: Marshall Jones Co., 1917.

Dunlop, Ian. The Cathedrals Crusade, The Rise of the Gothic Style in France. New York: Taplinger Co., 1982.

Fitchen, John. The Construction of Gothic Cathedrals. Oxford: The Clarendon Press, 1961.

Geissbuhler, Elisabeth Chase, trans. Cathedrals of France. By Auguste Rodin. Black Swan Books Ltd., 1965.

Gimpel, Jean. The Cathedral Builders. New York: Grove Press, Inc., 1980.

Henderson, Helen. Cathedrals of France. Houghton Mifflin Co., 1929.

Howgrave-Graham, R.P. The Cathedrals of France. London: B.T. Batsford, Ltd., 1959.

Jackson, Sir Thomas Graham. Gothic Architecture in France, England & Italy. 2 vols. Cambridge: Cambridge University Press, 1915.

Jantzen, Hans. High Gothic: The Classic Cathedrals of Chartes Reims and Amiens. Minerva Press, 1962.

L'Architecture Gothique Dans L'Ouest de la France. Paris: J. Pichard, 1963.

Lesser, George. Gothic Cathedrals and Sacred Geometry, Vol. 1. London: Alec Tiranti Ltd., 1957.

Male, Emile. Religious Art in France: The Thirteenth Century. Princeton University Press, 1984.

Mark, Robert. Experiments in Gothic Structure. Cambridge: MIT Press, 1982.

O'Reilly, Elizabeth. How France Built Her Cathedrals. New York: Harper & Brothers, 1921.

Parkhurst, Helen Huss. <u>Cathedral: A Gothic Pilgrimage</u>. Boston: Houghton Mifflin Co., 1936.

Prentiss, Sartell. <u>The Heritage of the Cathedral</u>. New York: William Morrow & Co., 1936.

Taylor, William, and Robert Mark. "The Technology of Transition: Sexpartite to Quadripartite Vaulting in High Gothic Architecture." <u>The Art Bulletin</u> Dec. 1982: 579-586.

Von Simpson, Otto. <u>The Gothic Cathedral</u>. Princeton University Press, 1956.

Chapter 3

The Italian Renaissance: The Rebirth of the Visual Language of Ordering Space

In the Renaissance, spatial relationships take on new meaning with the development of the science of perspective. The illusion of three dimensional space is more clearly rendered. Forms occupy their own space rather than merely overlapping one another. Brunelleschi experimented with the use of perspective as an organizing tool for the creation of his architecture. Even though the Renaissance artists perfected the use of perspective, the roots of this "new" ordering system can be traced back to ancient Greek and Roman architecture. How did this new way of ordering space affect the architecture and painting of the Renaissance? The purpose of this work is to compare the Holy Trinity by Masaccio and the Pazzi Chapel by Brunelleschi to discover the ordering systems that were employed in each work and how these structures relate to the theories of both classical times and the Renaissance.

In the Middle Ages, space was rendered according to a hierarchical system using such techniques as overlapping, positioning of the figure on the picture plane, and size relationships. If a painter wanted to show the importance of Mary, he would place her higher in the picture and make her larger than surrounding figures. Cimabue, in his Madonna Enthroned with Angels and Prophets, uses these techniques. How did the development of linear perspective and the application of classical principles of ordering space change the appearance of Renaissance painting?

35

To understand the Renaissance and the works associated with it, one must understand the terms "Renaissance" and "humanism". The meaning of the term Renaissance has changed throughout the ages, and some art historians have argued for the abandonment of historical periods completely. To many, the Renaissance was considered a rebirth. The question is, of what was the Renaissance a rebirth? The Middle or Dark Ages was a period that was dominated by the Church. To the people of the Middle Ages it was far from being a dark age as they felt that they were enlightened by the true source of knowledge revealed to them by God. The Renaissance was a rebirth of the antique cultures of Greece and Rome and especially the writings of those periods. To understand the Renaissance we must understand the term "humanism" as it is associated with the Renaissance and Classical studies. It was not so much philosophy that the humanists were concerned with but the study of the Greek and especially, the Latin classics. Today the term has been loosely associated with almost any concern with human values. Many art historians use the term with a vague modern meaning and discuss Renaissance humanism, Medieval humanism, or Christian humanism. Because of this confusion it is important to try to recover the original meaning again so that we can discuss the classical Greek influence on the works of the Renaissance.

According to Paul Kristeller,

> The term <u>humanismus</u> was coined in 1808 by German educator F.J. Niethamnner to express emphasis on the Greek and Latin classics in secondary education. This word, however, was derived from the word humanist, which can be traced back to the Renaissance and the word <u>humanista</u>. The term <u>humanista</u> in Latin is a term commonly used in the sixteenth century for the professor, teacher, or student of the humanities.

The word humanista was, in turn, derived from an older term, "humanities," or <u>studia humanitatis</u>, which was used in the general sense of a liberal or literary education by ancient Roman authors such as Cicero and Gellius. By the first half of the 15th century <u>studia humanis</u> came to stand for a clearly defined cycle of scholarly disciplines involving grammar, rhetoric, history, poetry, and moral philosophy.[1]

Gombrich, in his work <u>From the Revival of Letters to the Reform of the Arts: Niccolo Niccoli and Filippo Brunelleschi</u>, states that, "The Renaissance was the work of the humanists. But to use this term no longer denotes the heralds of a new 'discovery of man,' but rather the <u>humanisti</u>, scholars, that is, who are neither theologians nor physicians but rather concentrate on the 'humanities,' principally the trivium of grammar, dialectic and rhetoric."[2]

It is the classical Greek and Roman influences on the thoughts of the Renaissance artists that is significant to understand regarding their works. Does Brunelleschi use a similar system of ordering space in his architecture? Vitruvius lists six fundamental principles of architecture: order, arrangement, eurythmy, symmetry, propriety, and economy. Order, according to Vitruvius, had to do with the measure of the structure according to mathematical modules and the agreement of those parts to the whole so that an elegance of effect was created by their arrangement. The Classical architect was interested in this coherence of the structure, and John Summerson states in his book, <u>The Classical Language of Architecture</u>, that "The aim of classical architecture has always been to achieve a demonstrable harmony of parts." Vitruvius is confusing, however, because he states that eurythmy is also an adjustment of the parts to the whole so that they are in harmony. The Vitruvian definition of symmetry is not the

same as the modern definition that everything on one side of a picture or architectural facade is the mirror image of the opposite, but that of <u>symmetria</u>, in which the parts are related to the whole and form a unity. He uses the example of the human body as an analogy, stating that there is a symmetry between a forearm and a foot, for example. So in essence, the first four principles have to do with the ordering of the "parts to the whole." "Propriety," he says, "is that perfection of style which comes when a work is authoritatively constructed on approved principles." These principles were derived from the previous usage of the Greeks and from nature. By this he means being derived from geometrical forms that are found in nature or the proportions of the human body. Economy he relates to thrift in choosing building materials that are close at hand and which are therefore not as expensive as imported materials. Also associated with the notion of propriety, Vitruvius connects the idea of building structures to the status of the inhabitant; if the person is wealthy, the structure should be luxurious, but if the person is poor, the structure should be small and unpretentious.[3]

Vitruvius was known to Renaissance artists and writers. Alberti essentially copied much of the work of Vitruvius in writing his <u>Ten Books on Architecture</u>. Alberti narrows the six important elements of architecture down to three: number, measure, and arrangement. Beauty, according to Alberti, depends on these three ingredients. Beauty, in other words, has to do with rationality—once again, the mathematical arrangement of the units in relationship to the whole structure.[4] Neither Masaccio nor Brunelleschi had the opportunity to be influenced by Alberti's thought; however, this principle of organization using proportion based on mathematics and unity is the common element that Vitruvius, Brunelleschi, and Alberti had in common.

Brunelleschi painted two panels in the course of an experiment in perspective. Although these two panels do

not survive, we know that they correctly embodied the use of linear perspective. The first panel was a view of the Church of San Giovanni di Firenze, also known as the Baptistry of Florence. Manetti states that in order to help the viewer to keep his eye at the center of projection, Brunelleschi "had made a hole in the panel on which there was this painting; ... which hole was as small as a lentil on the painting side of the panel, and on the back it opened pyramidally, like a woman's straw hat, to the size of a ducat or a little more. And he wished the eye to be placed at the back, where it was large, by whoever had it to see, with the one hand bringing it close to the eye, and with the other holding a mirror opposite, so that there the painting came to be reflected back; ... which on being seen it seemed as if the real thing was seen: I have had the painting in my hand and have seen it many times in these days, so I can give testimony."[5] His second experiment was a two-point perspective of the palace and piazza of the Signora of Florence. These experiments show that the quest of Brunelleschi was for a rational, mathematical ordering of space.

Both Manneti and Vasari claimed that Brunelleschi had gone beyond these experiments and had actually created perspective. Here is Manetti's account: "Thus in those days he himself proposed and practiced what painters today call perspective; for it is part of that science, which is in effect to put down well and within reason the diminutions and enlargements which appear to the eyes of men the things far away or close at hand: buildings, plains, and mountains and countrysides of every kind and part, the figures and other objects, in that measurement which corresponds to that distance away which they show themselves to be: and from him is born the rule, which is the basis of all that has been done of that kind from that day to this." Fanelli says that Brunelleschi collaborated with Masaccio in the drawing of the perspective of his <u>Holy Trinity</u>. These experiments show that the quest of Brunelleschi was for rational, mathematical ordering of

space. Does Brunelleschi use a similar system of ordering space in his architecture?

The Pazzi Chapel was once thought the culmination of the work of Brunelleschi, but that is now in question. The front facade does not seem to be the type of work that Brunelleschi would accomplish in the later part of his career; it does not have a pediment, the interior structure is continued on the outside, and there are strigils in the frieze which are derived from Roman sarcophagi. It is suggested by Eugenio Battisti that this style of ornamentation was the work of his followers as he did not use this style in any of his previous works. Battisti goes so far as to say that, "The front displays a splendid portico, inspired by triumphal arches like that at Civita Castellana: its design, however, is completely autonomous and has nothing to do with Brunelleschi."[6] This seems to be an overstatement, because even if Brunelleschi did not design the facade, he may have had a partial influence in the design. There is no written documentation that can confirm or deny Brunelleschi's part in the facade, or for that matter, the whole structure. Given the nature of this paper, it will suffice to mention the problem and not get caught up in the debate. For the purposes of this comparison, I will refer to the Pazzi Chapel as Brunelleschi's work.

The Pazzi Chapel was probably begun in 1429-30, after the completion of work on the sacristy at San Lorenzo. The interior was completed in 1944; the dome was vaulted in 1461, according to an inscription on the dome itself. The structure was intended as a chapter house with a chapel situated behind the altar where the family of the patron was permitted to bury its dead. The plan is essentially the same as the Old Sacristy except the square space of the main area is enlarged to become a rectangle. The dome is placed above the central square and the two lateral arms are barrel vaulted. A bench runs along the floor level of the main room and acts as a base for the pilasters. Brunelleschi further developed the solution used in the Old Sacristy and achieved a maximum of unity of design.[7]

There is certainly an interest in symmetry (in the modern sense and in the Vitruvian) and order in the Pazzi Chapel. There is a harmony in the adjustments of the vertical members. The facade is symmetrically divided with a series of three columns with Corinthian capitals on each side. Above it is a frieze with roundels. In the pediment is a series of double pilasters. Another frieze above this contains strigils. The facade is reminiscent of triumphal Roman arches. Behind the portico is the original facade which is symmetrically composed of arched windows between tall pilasters. There is a direct correspondence between the exterior and interior of the structure. On the wall facing the entrance are four sunken panels corresponding to the exterior windows, and they are articulated with pilasters on each side. There are roundels above each of these panels and this motif is continued around the corners. A frieze runs above the pilasters corresponding to the exterior facade, and above it is the arch framing the <u>scarcella</u>. The pilasters and vaults contribute a rhythmic feeling as well as a unifying aspect to the interior. Even the floors are laid out with a grid pattern executed in Pietra Serena and Carrara marble that corresponds to the location of the pilasters. The equal divisions of space lend to a feeling of overall unity and order in the Pazzi Chapel.

The interior surfaces in the Pazzi Chapel are articulated by the use of pilasters which delineate the basic units of measurement. The front wall is divided into six areas of equal measurement. Visually the spaces between the pilasters on either side of the doors are equal; there is the larger area which is interrupted by the door. Notice that this area is also divided; however, this time not by a pilaster, but by a bracket below the frieze that visually marks off the same distance as between the pilasters. The back wall corresponds to this same arrangement with the area that contains the altar fitting between the two units of the module.

According to Giovanni Fanelli, "The length of a side of the square of the main space is identical to that of the Old

Sacristy; the side of the apse, however, is longer, so that the interval between the pilasters at the entrance is approximately twice the width of the wall surface between the pilasters which frame the apse and the pilasters at the (imaginary) corner of the (imaginary) square of the main space. This surface in turn is equal to the one next to it which creates the lateral extension of the main area." Brunelleschi has ordered the measurements of the Pazzi Chapel according to a consistent module with ratios that are equal. He arranges these modules in a symmetrical fashion. Fanelli gives precise measurements in his book, Brunelleschi, where he states, "If we call a side of the square of the main space 1, then the height of the pilasters, from the bench to the trabeation, is equal to 3/4 1; and the distance from the trabeation to the intrados of the arch is equal to 1/2 1 (the ratio between the two measures is 1.5:1.). If we measure the interaxial distances, the order (including the pilaster and the trabeation) equals 15 braccia, and the proportion between the interaxial distance (counting between the corner pilaster and the one adjacent to it) and the height is 1:3. The equivalence established between the real depth and the illusion of depth "drawn" on the wall ... is also present here in that the design of the three walls of the main space reproduces exactly that of the fourth wall which opens onto the altar space."[8] Ordering of space in the Pazzi Chapel is achieved by arranging the parts of the structure into equal units. The ordering of these modules creates a harmony between the parts of the building and the whole.

Propriety is evident in the Pazzi Chapel in that it greets one with an entrance portico that is adequate but not overpowering for the size of the chapel itself. This was important to Vitruvius, as he states that, "Buildings having magnificent interiors are provided with elegant entrance-courts to correspond; for there will be no propriety in the spectacle of an elegant interior approached by a low, mean entrance." The entrance must be appropriate for the size and function of the architecture. Propriety is also evident in

the sense that the structure is a centralized plan that was "constructed on approved principles."[9] According to Vitruvius, if the architect used the temples of the ancients as prototypes, then the structure would be proper according to the authority of the buildings themselves. The centrally planned church or "temple" was the ideal of the Renaissance. The circular plan was thought to be the best, as the circle had no beginning or end and was symbolic of perfection. The prototypes for the centralized plan were various. In practice, many of the original "Greek" buildings that were copied were in actuality Romanesque, such as the Baptistry in Florence. However, a clear Christian source was the tradition that connected the Virgin with the circular church. The Virgin is often depicted in paintings with the temple of Jerusalem, popularly believed to have been a centralized structure. Alberti's De re aedificatoria contains the first complete Renaissance treatise of the ideal church plan. In the seventh book of this work he deals with the building and decorating of church architecture. Alberti starts out by recommending the circle as the most perfect of geometrical shapes for the building of temples. The circle is commonly found in nature, and he declares that, "Nature enjoys the round form above all others."[10] In all, Alberti recommends nine geometrical shapes that are suitable to architecture: "The circle, the square, the hexagon, the octagon, the decagon, and the dodecagon, which are all based on the circle, following which he mentions three shapes based on the square: the square plus one-half, the square plus one-third, and the square doubled."[11] In the Pazzi Chapel Brunelleschi uses the square plus one-half added to each end.

Economy is used by Brunelleschi in that there is no excessive ornamentation in the Pazzi Chapel. The walls are articulated simply by the use of pietra serina pilasters with white plaster between. Eliminating any use of fresco painting creates an overall contemplative effect. The Pazzi Chapel is a centralized plan which is based on the circle and square, with extensions on each end, making it into a

rectangle. The Vitruvian circle and square were considered the most economic of geometrical shapes. The classical principles outlined by Vitruvius are certainly adapted by Brunelleschi and put to use in the Pazzi Chapel to simplify and unify the structure. Does Masaccio use similar spatial organization principles in his Holy Trinity?

Perspective can be thought of as rationalized observation of nature. The Greeks and Romans observed nature and then tried to paint as they observed it to be. Their observation and subsequent rendering was based more on the imagination. In the Renaissance, imagination diminished and mathematics, rationality, and the precise drawing of linear illusions on paper became important. This was opposed to the method used previously, that of the idea being composed in front of the wall to be painted. The Renaissance artist worked long hours, bent over his drawings in the workshop and then transferred these drawings to the wall by the means of a cartoon.

Masaccio is an intermediary; he did not draw a cartoon on the wall; however, he incised lines right into the plaster. He used geometrical forms, i.e. the triangle, circle, and S-shape as a means of creating the illusion of deeper space in his painting. Previously, many of the plans did not use these forms in the same way; they may have been used symbolically, i.e. the circle as a symbol of perfection, but not as a perspective tool.

Linear perspective was used in Greek and Roman Art in the later periods, starting around 530-100 B.C. Vitruvius mentions the use of scaenographia when he states, "In like manner scaenographia is the method of sketching a front with the sides withdrawing into the background, the lines all meeting at the center of a circle,"[12] and, "given a certain central point the lines should correspond as they do in nature to the point of sight and the projection of the visual rays, so that from an unclear object a clear representation of the appearance of buildings might be given in painted scenery, and so that, though all is drawn on vertical and plane surfaces, some

parts may seem to be withdrawing into the background and others to be protruding in front of it."[13] Masaccio uses the knowledge of perspective that the Greeks understood, but carries it further in practice. In Greek paintings the perspective doesn't look convincing as it does in Masaccio's work.

The <u>Holy Trinity</u> is a fresco which is located near the middle of the left aisle wall of the Dominican church of Santa Maria Novella in Florence, Italy. It is dated either 1427 or 1428, but in any case, shortly before Masaccio's departure for Rome. The <u>Holy Trinity</u> of Santa Maria Novella was originally hidden by an altar, and it was not until the church was reconstructed in the sixteenth century that it was discovered and relocated to a position near the church entrance. The <u>Holy Trinity</u> is composed within a great architectural frame very suggestive of Brunelleschi's style. The fresco is composed of a skeleton at the bottom section. Above the skeleton is a <u>momento mori</u> epitaph which reads, "I was once that which you are, and what I am you will be."[14] in the upper section are two kneeling donors, Mary, St. John the Evangelist, God the Father, The Holy Spirit represented as a dove, and the crucified Christ. Two pilasters topped by Corinthian capitals hold an entablature that encloses the upper limit of the work. There are four Tuscan Doric columns supporting a coffered barrel vault that covers the room.[15]

Linear perspective is used to give the illusion of depth, and the space seems quite deep. Order, eurythmy, and symmetry in Masaccio's <u>Holy Trinity</u> are due to his mastery of one-point perspective which allowed the construction of rational, measurable environments. Perspective is used by Masaccio as a unifying tool in the <u>Holy Trinity</u> by creating the illusion of three-dimensional space.

Masaccio's <u>Holy Trinity</u> is symmetrical in the modern sense of the term. If one drew an imaginary line down the center of the painting, the architecture at least would be exactly the same on both sides. The figures would not be identical; however, the space the figures occupy is the

same. In the <u>School of Athens</u>, Raphael incorporates the concept of a space that is geometrically solid. Each individual appears to have volume. Early Renaissance space, on the other hand, was ambiguous and less defined by volume. Masaccio was a friend of Brunelleschi and undoubtedly was influenced by his use of perspective. In the <u>Holy Trinity</u>, Massacio uses one-point perspective to draw one's eye through the illusion of deep space and to focus attention on the Trinity. Masaccio has been recognized as the artist who used the rules of perspective and applied them to painting. The people in his paintings, for the first time, start to look as if they fill their proper space. Giotto had a problem with rendering individuals within their proper environment. His architecture is proportionally inaccurate, and people look flat at times and not in their proper relationship to other people and objects.

Masaccio applies the rules of perspective in the Holy Trinity but allows for the adjustment of the eye also. Much has been said about the ambiguous nature of the placing of Christ: however, according to the eye, his position looks clearly to be in the center of the barrel vault and in front of God the Father. Many scholars mention that his perspective is not perfect, that it is hard to tell whether Christ is located in the middle ground or background. However, when one looks at the work as a whole, the question does not even present itself to the viewer; everything seems to work together as a whole.

Masaccio did not conquer space by the use of perspective alone; he used light: however, not in a haphazard manner or theatrical way, but in a very regulated sense, by allowing the light to strike the architecture and the figures from a fixed source located in the upper left-hand corner. Alberti translates the Latin <u>prominentia</u> (projection) as <u>rilievo</u>, which is similar to <u>chiaroscuro</u>, but not exactly the same. The difference lies in the fact that <u>chiaroscuro</u> was used with no relation to the light source. It was a technique used for modeling, but the only criterion used was that highlights went on high spots and darks on low areas.

So, one could have many opposing light sources in one painting. <u>Rilievo</u> of the Renaissance assumed a single dominant light source with subsequent shadows falling in relation to this source. Masaccio's subtle <u>rilievo</u> in gradations from light to dark help to model the figures and architecture, thus giving them a sense of distance from each other. This sense of distance created by shading the figures is one method that Masaccio used to create the illusion of depth in his painting. The use of <u>rilievo</u>, plus the use of perspective, allowed Masaccio to create a sense of reality that was not previously seen in painting.[16]

Both Brunelleschi and Masaccio used organizing methods in their works that created clear spatial relationships. These relationships were based on the classical principles of order and proportion that were derived from Vitruvius and other classical sources. These principles, along with the new perspective principles worked out by Brunelleschi, allowed him and Masaccio to manipulate space. Masaccio created a more believable illusion of three-dimensional space on a two-dimensional surface than had been previously achieved. Brunelleschi created a relationship between the parts of the Pazzi Chapel and the whole of the building through the use of mathematics and repetition of modules, which gave a person the feeling of unity and wholeness that was desired in a church structure.

Chapter 3 Notes

1. Paul Oskar Kristeller. <u>Renaissance Thought: The Classic, Scholastic and Humanistic Strains</u> (Harper and Bros., 1961). 9 & 10.
2. E.H. Gombrich. <u>The Heritage of Apelles: Studies in the Art of the Renaissance</u>. "From the Revival of Letters to the Reform of the Arts: Niccolo Niccoli and Filippo Brunelleschi," (Cornell University Press, 1976). 93.
3. Vitruvius. <u>The Ten Books on Architecture</u>, trans. by Morris Hickey Morgan (Harvard University Press, 1926). 13-16.
4. Leon Battista Alberti. <u>The Ten Books on Architecture</u>, the 1755 Leoni Edition (Dover Publishers, 1986).
5. Antonio Manetti. <u>The Life of Brunelleschi</u> (Translated by White, 1968). 114-17.
6. Eugenio Battisti. <u>Filippo Brunelleschi</u> (1981). 222.
7. Giovanni Fanelli. <u>Brunelleschi</u> (Scala Books, 1980). 53.
8. Fanelli. 53, 64.
9. Vitruvius. <u>The Ten Books on Architecture</u>. Trans. Morris Hicky Morgan. New York: Dover Publications, Inc., 1960.
10. Leon Battista Alberti. <u>The Ten Books on Architecture</u>, the 1755 Leoni Edition (Dover Publishers, 1986.)
11. Ibid.
12. Vitruvius. <u>The Ten Books on Architecture</u>.
13. Ibid.
14. Frederick Hartt. <u>History of Italian Renaissance Art</u> (Prentice Hall & Harry Abrams, 1985). 205, 206.
15. Ibid.
16. Lawrence Wright. <u>Perspective in Perspective</u> (Routledge & Kegan Paul, 1983). 60, 61.

Bibliography

Alberti, Leon Battista. On Painting and on Sculpture. Translated by Cecil Grayson. London: Phaidon Press, Ltd., 1972.

Argan, Giulio Carlo. Brunelleschi. Arnoldo Mondadori, Editore, 1952.

Battisti, Eugenio. Filippo Brunelleschi. New York: Rizzoli, 1981.

Berti, Luciano. Masaccio. The Pennsylvania State University Press, 1967.

Burckhardt, Jacob. The Architecture of the Italian Renaissance. Chicago: The University of Chicago Press, 1985.

Cole, Bruce and Florence. Masaccio and the Art of Early Renaissance. Indiana University Press, 1980.

Fanelli, Giovanni. Brunelleschi. Becocci, Editore. Firenze, 1977.

Gadol, Joan. Leon Battista Alberti—Universal Man of the Early Renaissance. Chicago: The University of Chicago Press, 1969.

Gombrich, E.H. The Heritage of Apelles—Studies in the Art of the Renaissance. New York: Cornell University Press, 1976.

Greenhalgh, Michael. The Classical Tradition in Art. New York: Harper & Row, 1978.

Heydenreich, H. and Wolfgang Lotz. Architecture in Italy, 1400 to 1600. Penguin Books, 1974.

Hyman, Isabelle, ed. Brunelleschi in Perspective. Prentice-Hall, Inc., 1974.

Janson, H.W. "Ground Plan and Elevation in Masaccio's Trinity Fresco." (One of the essays in the History of Art presented to Rudolf Wittkower.) London: Phaidon Press, 1967.

Kristeller, Paul Oskar. Renaissance Thought. New York: Harper & Bros., 1961.

Kubovy, Michael. The Psychology of Perspective and Renaissance Art. Cambridge University Press, 1986.

L'Opera Completa De Masaccio. Milano: Rizzoli, Editore, 1968.

Lotz, Wolfgang. *Studies in Italian Renaissance Architecture*. The M.I.T. Press, 1977.

Manetti, Antonio Di Tuccio. *The Life of Brunelleschi*. The Pennsylvania State University Press, 1970.

Murray, Peter. *Architecture of the Renaissance*. Harry N. Abrams, Inc., 1971.

Panofsky, Erwin. *Idea—A Concept in Art Theory*. University of South Carolina Press, 1968.

_____. *Renaissance and Renascences in Western Art*. Uppsala: Almquist & Wikseus, 1960.

Procacci, Ugo. *All the Paintings of Masaccio*. New York: Hawthorn Books, Inc., 1962.

Scott, Geoffrey. *The Architecture of Humanism*. Gloucester, Mass.: Peter Smith, 1965.

Sypher, Wyle. *Four Stages of Renaissance Style*. Doubleday & Co., Inc., 1955.

The Renaissance and Mannerism, Studies in Western Art. Vol. 11, Princeton University Press, 1963.

Vasari, Giorgio. *The Lives of the Artists*. Penguin Books, 1965.

White, John. *The Birth and Rebirth of Pictorial Space*. Boston: Boston Book and Art Shop, 1967.

Wittkower, Rudolf. *Architectural Principles in the Age of Humanism*. New York: W.W. Norton & Co., 1971.

Chapter 4

Dynamics: Baroque Movement and Order

Descartes was thought of as propounding a threatening new philosophy that would undermine the Scholastic system. Scholasticism, as a system, was derived ultimately from Aristotle and was carried out through the Middle Ages, Renaissance, and into the Baroque period. The main problem that the Scholastics faced was the reconciliation between faith and reason. The Schoolmen produced logical techniques of argumentation used to prove their theories. St. Thomas Aquinas, in his <u>Summa Theologica</u>, used the Scholastic method. He used scriptural texts and other authorities to back up his arguments. The method itself was to list the arguments <u>contra</u> one at a time and refute them with arguments <u>pro</u>. It was a process of not giving the other side a chance to refute their arguments while one builds up proofs that are thought to be irrefutable. It was a manipulation of the data and persuasive argument based on authorities. It is this system against which Descartes argued. Descartes was not against logical thinking, but against the way that it was being used. The Scholastic method had become a very rigid system that at times was used without thought as to how it was applied.

The central idea of Descartes' philosophy, according to John Cottingham, was "a very simple one: That the truth, so far from being shrouded in mystery, was readily acceptable to the ordinary human intellect, if only it could be directed aright."[1] Descartes' method went against the Scholastic system in the sense that he did not think that the logical syllogisms the Scholastics taught were always

used in a valid manner. The standard Aristotealian triadic pattern for the syllogism is the major premise, followed by the minor premise, and finally, a conclusion. Logicians since Aristotle have distinguished valid syllogisms from invalid ones. Compare the two following Syllogisms:

All men are mortal	major premise
Socrates is a man	minor premise
Therefore, Socrates is mortal	conclusion

All men are two-legged	major premise
All pigeons are two-legged	minor premise
Therefore, all men are pigeons	conclusion

Since the first syllogism is valid and its premises are true, its conclusion is also true. In the second syllogism the conclusion is false because the argument fails to realize that there may be more than one class of two-legged creatures.

Probably the best known fact about Descartes' method is the statement cogito ergo sum (I am thinking, therefore I exist) which occurs in his Principles of Philosophy.[2] According to John Cottingham, some scholars have understood this statement to be part of a syllogism similar to the ones described above with a major premise, minor premise, and conclusion. They reason it should read something like this:[3]

Whatever is thinking, exists	major premise
I am thinking	minor premise
Therefore I exist	conclusion

Descartes himself makes it clear that this is not what he had in mind in his second set of objections, when he states, "When someone says, 'I am thinking therefore I am, or exist,' he does not deduce existence from thought by

means of a syllogism but recognizes it as something self-evident by a simple intuition of the mind. This is clear from the fact that if he were deducing it by means of a syllogism he would have to have previous knowledge of the major premise 'Everything which is thinking is, or exists;' yet in fact he learns it from experiencing in his own case that it is impossible that he should think without existing. It is in the nature of the mind to construct general propositions on the basis of our knowledge of particular ones."[4] Descartes specifically states that he is not reasoning on the basis of a syllogism.

Descartes proposes a system that starts from <u>intueri</u> rather than a set of preconceived presuppositions. In his <u>Opera Posthuma</u>, Rule III, he states, "As regards any subject we propose to investigate, we must inquire not what other people have thought, nor what we ourselves conjecture, but what we can clearly and manifestly perceive by intuition or deduce with certainty. For there is no other way of acquiring knowledge."[5] He does not mean intuition in the modern sense of a mysterious irrational event that sparks the imagination. He gives a full definition of what he means by intuition in the <u>Regulae</u>:

> By intuition I do not mean the fluctuating testimony of the sense, or the deceptive judgement of the imagination as it botches things together, but the conception of a clear and attentive mind, which is so easy and distinct that there can be no room for doubt about what we are understanding. Alternatively, and this comes to the same thing, intuition is the indubitable conception of a clear and attentive mind which proceeds solely from the light of reason ... Thus everyone can mentally intuit that he exists, that he is thinking, that a triangle is bounded by three sides and a sphere by a single surface, and the like.[6]

The Latin verb means "to see" or "to look upon." He means that one can learn far more than thought possible just by close observation of an object. In Rule XII he uses the example of shape. He says that we should use all the senses in perceiving shape and not only the tactile senses. Shape is both seen and felt. Descartes says:

> The concept of shape is so common and simple that it is involved in every sensible object. For example, on any view of colour it is undeniably extended and therefore has shape. Let us beware of uselessly assuming, and rashly imagining, a new entity; let us not deny anyone else's view of colour, but let us abstract from all aspects except shape, and conceive the difference between white, red, blue, etc., as being like the differences between shapes such as these:[7]

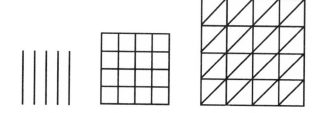

In other words, Descartes believes in deductive reasoning rather than inductive reasoning.

To Descartes, experience is important to his system. If we look at the detailed descriptions of the structure of the physical world, we note that they are very simple and homely. For example, in his <u>Principles of Philosophy</u> he states:

> In a river there are various places where water twists around on itself and forms a whirlpool. If there is a flotsam on the water we see it carried around with the whirlpool

and in some cases we see it also rotating about its own center; further, the bits which are nearer the center of the whirlpool complete a revolution more quickly; and finally, although such flotsam always has a circular motion, it scarcely ever describes a perfect circle, but undergoes some latitudinal and longitudinal deviations. We can without difficulty imagine all this happening in the same way in the case of the planets, and in this single account explain all planetary movements that we observe.[8]

To Descartes, the whole planetary system turns continuously like a whirlpool. In a general sense, the laws, mathematics, and geometry of Descartes are confirmed by everyday experience.

It is important to note that Descartes had three vivid dreams in his early life that convinced him that he should start a new philosophical system. In the first dream he was spun around in a whirlwind and could not walk. The second dream ended suddenly in a loud thunder clap. In the third dream he saw a book of verse, in which he found a quote from the <u>Ode of Ausonius</u> beginning with <u>Quod vitae sectabor iter</u>? ('What road in life shall I follow?'). It was the dream that confirmed his course in life. From these dreams he knew that he must follow the road of philosophy.

Carl Friedrich, in his book <u>The Age of Baroque</u>, states that Descartes' system of geometry was one of a process rather than rigidity when he says:

> Descartes' approach to geometry (and mathematics in general) may be called dynamic, in contrast to the static approach of classical Greek mathematics. He observed, so to speak, geometrical figures in the process of becoming, rather than contemplating them as fixed verities. More specifically he concerned himself, therefore, with the properties

of curves, which he undertook to describe by placing them within a system of co-ordinates, and then stating the relation of successive points on the curve to these coordinates in the form of equations.[9]

To apply Descartes' method as an analytical tool, keeping in mind that his method was dynamic, is the main focus of the following analyses. Therefore, it will not serve the purpose to isolate the Golden Mean or discover static forms in these works, but one will be looking for dynamic, growing, changing, moving, and contrasting forms. The Little Last Judgement by Peter Paul Rubens and Georg Friedrich Handel's Sonata Number Two for Oboe and Keyboard will be examined for the purpose of determining if they contain such forms and, if so, what techniques were used to create the forms.

In Descartes' theory of vision outlined in the Dioptrics, Descartes reasons that the perceived qualities of seen objects are light, color, position, distance, and size.[10] First, he discusses light and color as the only qualities belonging especially to the sense of sight. Position, he says, we perceive by our eyes and our hands, also by the clearness of confusion of the shape seen, and by the strength or weakness of the light. Talking about distance and size he states, "I need not, in conclusion, say anything special about the way that we see the distance and position of their parts."[11] The following analysis will pursue the qualities outlined by Descartes (light, color, position, distance and size) and how Rubens uses these elements to create depth and dynamic forms in his Little Last Judgement.

Light is used by Rubens to model his figures. The figures in the closer planes are well modeled using the chiaroscuro technique. The further back the figures recede, the smaller and less distinct they become. The illusion of three-dimensionality through the use of shading is also linked with the use of rilievo. Rilievo is similar to chiaroscuro, but not exactly the same. The difference lies

in the fact that <u>chiaroscuro</u> was used with no relation to the light source. It was a technique for modeling, but the only criterion was that highlights go on high spots and darks go on low areas. One could have many opposing light sources in one painting. <u>Rilievo</u> assumed a single dominant light source with subsequent shadows falling in relation to this source. Rubens' subtle <u>rilievo</u> in gradations from light to dark help to model the figures, thus giving them a sense of distance from one another. This sense of distance, created by shading the figures, is one method that Rubens employed to create the sense of depth in the <u>Little Last Judgement</u>.

Color is also used by Rubens to model his figures. He uses brush strokes to create a painterly effect which imparts dynamism and vitality to his forms. He simultaneously creates a sense of movement, fear, dread, joyousness, and spontaneity. The contours of the flesh are soft and they seem to absorb light. Atmospheric perspective helps to create the illusion of depth as there is a haze around some of the figures and halos of light around others. There are no laboriously prepared underdrawings in Rubens' work. He sketched the underdrawing in thin fluid paint. A method called <u>alla prima</u>, which means direct painting rather than building up layers of paint, was used by Rubens. He then worked quickly with the entire finished painting in his mind.

Overlapping of figures is another method that Rubens uses to create a sense of depth. If an object is in front of another object it appears to be closer. When the background is fuzzy it appears to be further away. Foreshortening is a method usually used to shorten an individual's limbs or body parts to make them appear to be in proper perspective. Foreshortening is used, for example, to portray the central figure with the shield. His head is forward and the legs appear to go back into space.

The various sizes of figures in the <u>Little Last Judgement</u> help to create a sense of depth. One usually interprets largeness in size to mean that an object is rela-

tively nearer; the smaller the object gets, the farther away it appears. Rubens places larger figures in the foreground space, and they diminish in size as they recede into the background. These bodies are not only rendered on one plane, but there are at least six layers or planes deep. Overlapping, plus the variations in size, creates the illusion of figures that occupy their own spaces.

The human body was a recurrent theme in Rubens' works. Rubens' painting of the <u>Little Last Judgement</u> is a swarm of bodies entangled among one another. The <u>figura serpentinata</u>, Greek S curve, or <u>contraposto</u>, is obviously a technique that was used by Rubens to create his bodies. <u>Contraposto</u> means a pose in which one part of the body is twisted in one direction and the other part twisted in the opposite direction. Movement is certainly a part of <u>contraposto</u>. Carl Friedrich in his book <u>The Age of the Baroque</u> comments about the movement in Rubens' paintings:

> With the inception of out period [The Baroque], Rubens began to dissolve the fixed and isolated figure of Renaissance painting. Figures were placed into more animated relations with each other, and an increasingly unified movement pulsed through his great canvases.[12]

The composition of the work is one of motion and movement involving the changing orientation of conic, spherical, and cylindrical forms. The action is formed by concentric ripples that fan out across the canvas in arabesques. Descartes discusses motion at length in his <u>Principles</u>. He uses the term <u>translatio</u>, which means motion in the sense of change of location, when he says, "the passing (<u>translatio</u>) of one part of matter, or of one body, from the vicinity of those bodies which immediately touch it, and which we regard as being in repose, into the vicinity of others."[13] Rubens uses <u>translatio</u> as he intertwines limbs, backs, bellies, wings, and drapery of one body with another.

There is a seeming chaos in Rubens' paintings which is expressed in a tumult of form and color; however, his composition is also balanced. Bodies are not just strewn across the canvas haphazardly. One may divide the <u>Little Last Judgement</u> into concentric spheres that radiate out from the center, as when a pebble is thrown into the water and ripples spread out in circular patterns. The compass point of the central sphere is located on the leg of a warrior carrying a shield. The shield is the central focus point of the painting which is enshrouded in a halo of light. Spirals of action extend outside of this main circle and flow back to the center. Two half spheres may be drawn to show the action above and below. There are not only circular or spiral forms in this work, but a fanning out process that is formed by a series of strong diagonal lines that all have a common origin in the lower right-hand corner of the painting. The bodies themselves are made up of cones, spheres, and cylindrical forms that are twisting in every conceivable direction. Artists consider this the <u>furia</u> of the figure. Rubens breaks with the cannons of proportion that were so important to the Greeks. It is a combination of overlapping, <u>chiaroscuro</u>, his use of color, and size relationships that create the dynamic figures in the <u>Little Last Judgement</u>, which can be likened to Descartes' dynamic use of geometry and his philosophy in general. Does Handel create a dynamic form in his Sonata Number Two for Oboe and Keyboard?

In Handel's Sonata Number Two for Oboe and Keyboard, the first movement is divided into an A,B,A,B,A,B,A form. Movement number two is divided into a C,D,C,D,C,D,C,D,C,D pattern. Movement three has a continuous form of its own, and so does movement four. One could consider movement three as an E form and movement four as an F form. Each individual movement is unique, so the overall form could be called an A,B,C,D, form. The internal phrases are related to one another. The tempo of movement one is in Larghetto, movement two is Allegro, movement three is Adagio, and movement four is

Allegro. There is a slow, fast, slow, fast relationship of the sections. The dynamics of the piece start softly, the second movement starts loudly, the third softly, and the final movement starts loudly. We then have a P,F,P,F relationship of the starting dynamics. The ending dynamics produce the same effect with a P,F,F,P,P,F relationship.

The form grows as the piece continues. The phrase lengths grow progressively longer as they get near the end of the piece. Finally the last two measures contrast with each other, similar to the internal contrasts of the first two measures. There is a relationship between the contrast of the A and B material in movement number one and the contrast between the C and D material in movement number two, and then finally the contrasts grow so that the two final movements are contrasted with each other. The larger rhythmic units within the first two movements are contrasted with smaller, more active rhythmic units. The sections which I have labeled A,B, and C,D can possibly be likened to two different affections operating within this piece. Movement three, which consists of less active rhythmic units, is contrasted to movement four. On a larger scale, the last two movements could be likened to the two affections that are contrasted within the smaller units of movements one and two.

A more detailed analysis of the first movement will provide a more complete example of these internal contrasts. Generally speaking, the melody of the oboe voice in movement one starts with longer note values followed by shorter note values, eighth to sixteenth notes. There is a contrast between the first three measures and the fourth and fifth measures. Measures one through three will be called A material: that contrasts with the B material in measures four and five. There is a difference in rhythmic character of the notes in section B. This B section starts with a dotted sixteenth note followed by thirty-second notes. The B material is not completely new but is contrasting material that has grown out of the A theme. These contrasting sec-

tions could be likened to two differing affections that delineate the sections of the melody.

The melody of the oboe part starts on a G, and G is a tonal center beginning in measure one as the accompaniment starts on a G minor chord. This tonal center is also created by the addition of an F# both in the accompaniment and in the melody, thereby creating the harmonic minor scale on G. In measure five, however, there is a V I cadence on B flat, creating B flat as a tonal center, and the melody ends the phrase on a B flat.

Measure six starts another A section with a G minor chord, but in measure eight there is an alternating B section that has a chordal progression with V I relationships. The harmonic progression consists of a series of dominant five chords in D minor, C minor, G minor, G major, and concludes with a G minor in measure sixteen. There is a D major that leads to a C minor and back to a G major in the A material starting in measure eleven. This G links the sections together harmonically.

Measures eight, nine, and ten do not maintain a tonal center of B flat as in measures four and five. In measure sixteen there is a V I cadence in G minor. The character of the cadence formula is not unlike the character of the entire piece, which is long-short. The movement concludes with a change in tempo from Larghetto to Adagio and ends on an authentic cadence in measure seventeen. This serves as a transition to the second movement which is in Allegro and also in G minor. Handel in this manner ties the first two movements of the form together into a larger unit.

There are similarities in the forms of Handel's Sonata and Rubens' Little Last Judgement. The structures of both works are dynamic rather than static. They both grow and expand and contrast. In the Little Last Judgement, Rubens contrasts the saved from the wicked, darkness and light, clear modeling in the foreground with sfumato or fuzziness as the figures recede into the background. Handel's Sonata contrasts slow and fast tempos, soft and loud dynamics, and smaller and larger rhythmic units

throughout the piece, culminating in a contrast between the last two movements, creating a widening, growing, expanding form. Rubens creates dynamic volumes moving in space through the use of techniques such as overlapping of planes, twisting of planes, and <u>chiaroscuro</u>. Handel creates a moving dynamic form by the use of two contrasting themes that grow and expand in time and space. These dynamic forms may be likened to the dynamic philosophy of Descartes rather than the static forms of the Scholastic system.

Chapter 4 Notes

1. John Cottingham, <u>Descartes</u>. (Basil Blackwell, 1986) 22.
2. Elisabeth Anscombe and Peter Thomas Geach, Trans. & Ed. <u>Descartes Philosophical Writings</u> (Indianapolis: Bobbs-Merrill Educational Pub., 1954) 183, 299.
3. John Cottingham, <u>Descartes</u>. 36.
4. John Cottingham, Robert Stoothoff and Dugald Murdoch. <u>The Philosophical Writings of Descartes</u>. Vol. 2, 100.
5. <u>Descartes Philosophical Writings</u>. 153.
6. <u>The Philosophical Writings of Descartes</u>. Vol. 1, 14.
7. <u>Descartes Philosophical Writings</u>. 167.
8. <u>The Philosophical Writings of Descartes</u>. Vol. 1, 254.
9. Carl J. Friedrich, <u>The Age of The Baroque: 1610-1660</u>. (New York: Harper and Row Pub., 1952.) 111.
10. <u>Descartes Philisophical Writings</u>. 247.
11. <u>Descartes Philosophical Writings</u>. 252.
12. Carl J.Friedrich, <u>The Age of The Baroque</u>. 74.
13. <u>The Philosophical Writings of Descartes</u>. 233.

Bibliography

Bazin, Germain. Baroque and Rococo Art. New York: Praeger Publishers, 1974.

Beck, C.J. The Method of Descartes. Oxford: The Clarendon Press, 1952.

Blume, Friedrich. Renaissance and Baroque Music. New York: W.W. Norton & Co., 1967.

Boroff, Edith. The Music of the Baroque. Iowa: Wm.C. Brown Co., 1970.

Bukofzer, Manfred F. Music in the Baroque Era. New York: W.W. Norton & Co., 1947.

Corley, E.M. Descartes Against the Skeptics. Cambridge: Harvard University Press, 1978.

Cottingham, John. Descartes. Basil Blackwell, Inc. 1986.

Cudworth, Charles, Linnet Books and Clive Bingley. Handel. 1972.

Dent, Edward J. Handel. New York: A.A. Wyn, Inc.

Descartes Philosophical Writings. Elizabeth Anscombe and Peter Thomas Geach, trans. and ed. Indianapolis: Bobbs-Merrill Educational Publishing, 1954.

Deutsch, Otto Erich. Handel: A Documentary Biography. New York: W.W. Norton & Co., Inc.

Downes, Kerry. Rubens. Jupiter Books, 1980.

Flower, Newman. George Frideric Handel: His Personality and His Times. New York: Houghton Mifflin Co., 1923.

Freiderich, Carl J. The Age of the Baroque: 1610-50. New York: Harper and Row, 1952.

Grove's Dictionary of Music and Musicians. Eric Blom, ed. London: Macmillan & Co., Ltd., 1961.

Handel: A Celebration of His Life & Times: 1685-1759. Jacob Simon, ed. London: National Portrait Gallery, 1986.

Handel: A Symposium. Gerald Abraham, ed. London: Oxford University Press, 1954.

Harman, Alec and Anthony Milner. Man and His Music: Late Renaissance and Baroque Music. New York: Schocken Books, 1962.

Harrison, S. J. C. The Great Centuries of Painting: The Seventeenth Century, The New Developments in Art

from Carvaggio to Vermeer, Jacques Dupont and Francois Mathey Troy. New York: Skira, Inc.

Held, Julius S., and Donald Posner. 17th and 18th Century Art: Baroque Painting, Sculpture, Architecture. New Jersey: Prentice Hall, Inc. and New York: Harry N. Abrams, Inc.

Hogwood, Christopher. Handel. Thames & Hudson, 1984.

Hourticq, Louis. Rubens. Fredrick Street, trans. New York: Duffield & Co., 1918.

Hubala, Erich. Baroque and Rococo Art. New York: Universe Books, 1976.

Jaffe, Michael. Rubens and Italy. Ithaca, New York: Cornell University Press, 1977.

Keates, Jonathan. Handel: The Man and His Music. New York: St. Martin's Press, 1985.

Kimball, Fiske. The Creation of the Rococo. New York: W.W. Norton & Co., 1943.

Knackfuss, H. Rubens. Louise M. Richter, trans. New York: Lemcke & Buechner, 1904.

List, Kurt. History of Baroque Music. New York: Orpheus, 1967.

Martin, John Rupert. Baroque. New York: Harper and Row, 1977.

Rea, Hope. Peter Paul Rubens. London: George Bell & Sons, 1905.

Ringenberg, Lawrence A. Informal Geometry. New York: John Wiley & Sons, Inc., 1967.

Rolland, Romain. Handel. London: Kegan Paul, Trench, Trubner & Co., Ltd., 1971.

Rosenberg, Adolf. The Work of Rubens. New York: Brentano's, 1921.

Rubens Before 1620. John Rupert Martin, ed. New Jersey: Princeton University Press, 1972.

Sadie, Stanley. Handel. London: John Calder Publishing, Ltd., 1962.

Shearman, John. Mannerism. Penguin Books, 1967.

Smith, Norman Kemp. New Studies in the Philosophy of Descartes. New York: Russell & Russell, Inc., 1966.

Smith, William C. Concerning Handel: His Life and Works. London: Cassell & Co., Ltd., 1948.

Stevenson, R.A.M. <u>Rubens Paintings and Drawings</u>. London: Phaidon Press, 1939.

<u>Studies in Renaissance and Baroque Art Presented to Anthony Blunt on His 60th Birthday</u>. Phaidon Press, Ltd., 1967.

Tapie, Victor L. <u>The Age of Grandeur: Baroque and Classicism in Europe</u>. London: Weidenfeld and Nicolson, 1957.

<u>Techniques of the Great Masters of Art</u>. New Jersey: Chartwell Books, Inc., 1985.

<u>The Geometry of René Descartes</u>. David Eugene Smith and Marcia L. Latham, trans., Dover Publications, 1954.

<u>The New Oxford Companion to Music</u>. Arnold Dennis, ed. 2 Vols. London: Oxford University Press, 1983.

<u>The Philosophical Writings of Descartes</u>. John Cottingham, Robert Stoothoff and Dugald Murdoch, trans. 2 Vols. Cambridge: Cambridge University Press, 1985.

Thomas, Brian. <u>Geometry in Pictorial Composition</u>. Oriel Press, 1969.

Wedgewood, C.V. <u>The World of Rubens</u>. New York: Time-Life Books, 1967.

Weinstock, Herbert. <u>Handel</u>. New York: Alfred A. Knopf, 1959.

Williams, C.F. Abdy. <u>Handel</u>. New York: E.P. Dutton & Co., 1901.

Wurtenberger, Franzepp. <u>Mannerism: The European Style of the Sixteenth Century</u>. Michael Heron, trans., New York: Holt, Rinehart & Winston, 1963.

Young, John Wesley. <u>Projective Geometry</u>. Chicago: The Open Court Publishing Co., 1930.

Young, Percy M. <u>Handel</u>. New York: Pellegrini and Cudahy, Inc., 1949.

Articles

Muller, Jeffrey M. "Ruben's Theory and Practice of the Imitation of Art," <u>Art Bulletin</u>, 64, Je 182, 229-74.

Taubes, Frederic. "Notes on the History of Oil Painting Techniques, Part 2: Rubens, Titian, Tintoretto, and El Greco," <u>American Artist</u>, 36, Jl '72, 22-7.

Chapter 5

Ingres and Delacroix: Nineteenth Century "Classical" Artists?

During my research concerning the Classic-Romantic dichotomy, many problems arose. I will be proposing more questions than I will be answering. There are probably no clear-cut answers to the problems proposed by the Classic-Romantic dichotomy.

Ingres is usually thought of as a classical artist and Delacroix as a romantic. I would like to suggest that Ingres could be thought of as a romantic and Delacroix classified as a classicist.

In my struggle to define Classicism and Romanticism, I made up a list of qualities that were usually thought of as Classical and ones that were commonly thought of as Romantic. At first, I thought I was getting somewhere by analyzing works using this list as the criteria to determine if a painting was classical or romantic, only to find out that this strict type of categorizing was not really helpful or applicable to nineteenth century painting.

However, I think that it was useful for me to define some of the intrinsic qualities of these paintings. So initially I would like you to use this list along with me in our analysis. (Intrinsic analysis of Turner and David.)

I would like to delineate some of the problems that arise when one tries to define Classicism and Romanticism.

First of all, the terms classic and romantic have different meanings, depending on the context in which they are used. Classicism is synonymous with the antique style of

the Greeks and Romans. The term classical can be used for the designation of a particular period such as, "The fifth century B.C." Strictly speaking the term NeoClassicism should be used when referring to the revived classicism of the nineteenth century.

When I talk of classicism however, I will be referring to the qualities of the antique style as they are applied to any period in history. Also, the term classic may refer to a judgement used to classify an object such as, "the best of its kind"; for example: a classic car. When I use the term, however, I will be using it as synonymous with the term classicism. The same holds true with the terms romantic and romanticism; I will be using them to refer to universal qualities which are apparent in the works of any period.

One of the problems that I want to address is just this fact, that Classicism and Romanticism as analytical terms can be applied to the art of any period. For example: it may be useful to discuss the classical qualities of a Mondrian as opposed to the romantic qualities of Jackson Pollack or the romantic tendencies of Rubens and the classical qualities of Poussin.

Another problem is that classical and romantic qualities may be applied to the same artist. For example it can be argued that Ingres only painted three purely classical paintings in his whole career:

<u>The Ambassadors of Agamemnon</u>,
<u>Romulus Conqueror of Acron</u>, and
<u>Tu Marcellus Eris</u>.

Many artists have painted what we consider both classical and romantic works during their lifetimes. Another problem that arises is that both classical and romantic qualities are often present in a single art work.

The fourth aspect of Classicism and Romanticism is what the artist thought of himself. Both Ingres and Delacroix thought of themselves as classical artists.

This raises yet a fifth problem, and that is the difference between what the critics and the art historians thought of them and what they thought of themselves.

Then, the critics and art historians differ in their opinions, So we have a very complex problem.

It seems that there has been a temptation to consider classicism and romanticism as extreme polarities, as opposites. During the middle of the eighteenth century, this dichotomy grew further and further apart according to the critics of that time. Appearing at the same time were two books that helped to separate the two camps. In 1755 Winkelmann published his <u>Reflections on the Imitation of Greek Art</u> which was to become the "Bible" of classicism.

In the following year Burke published his <u>Inquiry into the Origins of the Sublime</u> which described the aims of romanticism. The classicists aimed at simplicity. The romantics wanted art to excite the emotions. It was thought that classical art should be very rationally and intellectually conceived and that romantic art was the expression of the soul.

Inges was the official leader of the classical school; however, he didn't quite suppress the expressions of his own soul, and what are considered romantic qualities showed up in his art. Whether he did this consciously or not, the fact remains that he violated the classical dogma of the time and created his own romantic style even though he was shocked and puzzled when classical painters found his work non-classical.

Formal Analysis of Jupiter and Thetis, Ingres:

Notice the drapery that folds in rhythmic patterns and bunches. The drapery is important in itself because of the pattern that it makes. Ingres was considered Gothic in his application of drapery. In the late Gothic period, drapery in paintings was represented in exaggerated bunchings and knottings. This is in direct opposition to classical simplicity. The classical drapery was rendered close to the body so that the classical structure of the body would show through.

Notice that the proportions of the human figure are drastically elongated. The Greeks would have been

appalled at this deviation from the classical perfections and considered it dionysian.

Also, the painting evokes a sense of softness and warmness of flesh. That was achieved partly by his use of <u>chiaroscuro</u> and partly through his soft linear quality rather than rigid classical stiffness. This is definitely not a literary picture that merely records a historical event in a detached manner; but it is highly passionate, sensual, and emotional. It is what one would call the opposite of cold sculptured classicism.

Delacroix also considered himself a classicist and resented being classified with other romantic rebels, as he called them, such as Hugo or Berlioz. He regarded himself as a true classicist as opposed to the false classicists who merely imitated the classical precedents without understanding the classical spirit. True classicism to Delacroix was concerned with generalizing human experience into universal symbols. For example: to him venus was not merely a beautiful woman, but symbolized all beauty.

Delacroix never abandoned his preparatory sketches; in fact he made numerous sketches for each of his forms. The effect that looks like it was dashed off without prior thought, was in fact achieved painstakingly. His turbulent forms are as carefully thought out as David's static, stylized ones. His apparently spontaneous brush strokes that led the classicists to refer to him as a "drunken broom" were far from being rendered while in a drunken stupor; but in fact, they were produced with the same care and intellectualism as the classical painters. His colors which appear to swarm across the canvas are mixed and blended according to theories that were probably more highly developed than that of the classical painters.

Romanticism is emotional; but Delacroix's visual appearance of emotionalism was achieved intellectually. This paradox must be accepted if his works are to be more fully understood. Even Gros defended Delacroix's <u>Dante and Virgil Crossing the River Stix</u> as a classical work.

The Massacre at Chios was accepted by the jury for the exhibition at the salon as a fine example of conventional painting. The subject matter is an episode in the Greek and Turkish war. The population of the island of Chios where 100,000 Greeks lived was reduced to 9,000 in one of the most horrible massacres in history. What happened to this painting that caused a scandal was that Delacroix took the painting and repainted it in the interval between the time that it was accepted and the opening of the salon.

He had been inspired by a painting by John Constable called the Hay Wain. Constable painted by juxtaposing spots of color rather than blending them. The classical technique was to evenly smooth or blend from one tint to another which was accomplished by the use of special brushes. Delacroix had originally used this technique but then painted over the top of the surface and blended his colors together.

This inspiration from Constable started Delacroix on experiments that occupied him for the rest of his life. However, remember that Delacroix considered his color to be under the control of reason.

There are many problems that arise when one tries to categorize artists using the terms "classical and romantic." Works from all periods exhibit both classical and romantic qualities. An artist may do one work in a classical manner and another in a romantic style. Both classical and romantic tendencies may be apparent in the same work of art, and artists that consider themselves to be classical artists may exhibit romantic tendencies.

Romanticism seems to go deeper than a surface of strong light and shade, swirling action and broken color. Classicism seems to delve further than controlled outline, flat color, and symmetrical balance. Especially in the nineteenth century when the styles of classic and romantic seem to blend, it is important to look at each work individually and judge for yourselves if the work conveys more romantic or classical qualities thus giving an overall feeling of "classicism or romanticism." Therefore, I suggest

that in the nineteenth century that the terms classical and romantic should not be used in strict polarities or opposites, but they should be viewed as qualities that co-exist.

Intrinsic Qualities of Classical Painting

1. Static Poses
2. No brush strokes showing
3. Evenly "tinted" color
4. Little emotional involvement of painter through brush strokes; emotion evoked through gestures.
5. Restrained color
6. Classical subject matter - Greek, Roman or Religious
7. Nobility of subject matter
8. Static drapery
9. Proportions based on perfections

Intrinsic Qualities of Romantic Painting

1. Fluid poses
2. Brush strokes apparent
3. Uneven color
4. Emotion conveyed through the use of vivid color and use of dynamic line quality.
5. Dynamic Color
6. Contemporary subject matter
7. Common subject matter
8. Dynamic drapery
9. Irregular proportions

Bibliography

Barzun, Jacques. Classic, Romantic and Modern. Chicago: The University of Chicago Press, 1961.

Bortolatto, Cuiginae Rossi. Documentation. Delacroix. Paris: Flammarion, 1975.

Clark, Kenneth. The Romantic Rebellion—Romantic vs. Classic Art. New York: Harper & Row, 1973.

Delacroix. An exhibition of paintings, drawings and lithographs arranged by the Arts Council of Great Britain in association with the Edinburgh Festival Society, The Arts Council, 1964.

Des Landres, Yvonne. Delacroix: A Pictorial Biography, London: Thames & Hudson, 1963.

Eugene Delacroix: Selected Letters 1813-1863. Trans. Jean Stewart. London: Eyre & Spottiswoode, 1971.

Georgel, Pierre. Introduction. Delacroix. Paris: Flammarion, 1975.

Marchiori, Giuseppe. Delacroix. New York, New York: Grosset & Dunlap, 1969.

Monimeja, J. Ingres. Paris: Librairie Renouard.

Mras, George. Eugene Delacroix's Theory of Art. New Jersey: Princeton University Press, 1966.

Pach, Walter. Ingres. New York: Harper & Brothers, 1939.

Picon, Gaeton. Ingres. Geneva: Editions d'art Albert Skira, 1967.

Piot, René Les Palettes de Delacroix. Paris: Librairie de France, 1931.

Pool, Phoebe. Delacroix. Verona: The Hamlynn Publishing Group Limited, 1969.

Roger-Mark, Claude, and Sabina Cotté Delacroix. New York: George Braziller, Inc., 1971.

Rozen, Charles, and Henri Zerner. Romanticism and Realism: The Mythology of Nineteenth Century Art. New York: The Viking Press, 1984.

Schlenoff, Norman. Ingres: Les Sources Litteraires. Paris: Presses Universitaires de France, 1956.

Schlenoff, Norman. Romanticism & Realism. New York: McGraw Hill, Inc., 1965.

Spector, Jack J. The Murals of Eugene Delecroix at Saint Sulpice. New York, New York: The College Art Association of America, 1967.

Ternois, Daniel. Introduction. Ingres: Documentation Etture Came Sasca. Paris: Flammarion, 1971.

Vogt, Adolf Max. Art of the Nineteenth Century. New York: Universe Books, 1973.

Chapter 6

Organic Architecture: Frank Lloyd Wright

Frank Lloyd Wright was often misunderstood when he used the term "organic architecture," and it is often misused today. Organic architecture, to Frank Lloyd Wright, did not mean that one would build using only organic shapes. It did not mean that one would build using only one specific style of architecture called "organic." He meant that one would create the style most appropriate for a specific situation, unifying the style most appropriate for a specific situation, unifying nature and the structure. "If he was going to build a house on a hill, he did not level off the top of the hill to make it fit the house; he did quite the opposite. The house he built on a hillside did not ignore or deny its site, it dramatized it."[1] Wright believed that architecture should become a part and parcel of the landscape, and not impose itself completely against its surroundings like a modern skyscraper. Wright's Imperial Hotel and Fallingwater are two of the finest expressions of his philosophy of organic architecture.

Although built about twenty years apart, and in vastly different parts of the world, the former (located in an urban center) and the latter (situated in a rural setting) both have much in common, and teach us something of what Wright had in mind when he used the term organic architecture.

Frank Lloyd Wright's Imperial Hotel was planned between 1915 and 1917. In 1917 the construction began, and the hotel was opened in 1922. The building was functional until 1967.[2] This impersonal chronology states only the bare facts about a building that was a work of great

genius and artistic creativity. Obviously, a number of individuals did not recognize it as a valuable work of art or it would not have been carelessly destroyed.

When seeing the remaining photographs of this magnificent hotel one is overwhelmed with a sense of respect for the building. The building itself expresses that it is no ordinary structure, but rather a very dignified one. It is unified, solid, and massive, yet the perforations caused by overlapping geometric shapes gives one a sense of airiness, variety, and rhythm. Variations in texture occur as the rough, scored surfaces of the long brown bricks play against the carved geometric shapes in light yellow stone. This stone was easily carved, as it was actually a lightweight volcanic residue called "oya."

The building's interior is a symphony of rejoicing, as light flows in through the windows and strikes the many-faceted surfaces. Light and shadow dance together through the various inlets of brick, stone, and glass. Triangles, spheres, cubes, and other shapes are not only carved into the lava as a decoration, but also become a part of the structural supports, walls, and columns. There is an overall sense of majestic oriental simplicity, yet at the same time a dynamic complexity of intricate shapes pleases the eye.

Before Wright attempted to build the Imperial Hotel, he wanted to understand how the Japanese lived within their own homes.

> Cleanliness, simplicity and a respect for materials were the three cardinal virtues of the humblest of Japanese dwellings. Anything not used was to the Japanese out of place. The 'space within' was uncluttered by any objects other than those in immediate use—a low table, cushions on the floor, and, in a niche in the wall, a painting, a piece of sculpture, or a vase of flowers.[3]

Wright was interested in combining the religious beliefs of the Japanese, such as unity and simplicity, into a build-

ing that was going to be used by American businessmen. Wright declared,

> When I accepted the commission to design and build their building, it was my instinct and definite intention not to insult them. In short, I desired to help Japan make a transition from her knees to to her feet, without too great a loss of her own accomplishments in culture.[4]

When considering the site for the Imperial Hotel, he knew that Japan had a history of earthquakes that shook buildings to the ground. He spent six years on studies of earthquake conditions, and concluded that he should not build a rigid structure like the other buildings surrounding it, but must build a flexible structure.

The site consisted of sixty to seventy feet of soft mud, covered by approximately eight feet of earth the consistency of which he called "cheese." He decided to "float" the building on the mud, "like a battleship floats on the water." Wright was going to out-maneuver the quake instead of fighting it. He questioned, "Float the building on the mud? Why fight the force of the quake on its own terms? Why not go with it and come back unharmed? Outwit the quake."[5]

He created poured concrete for slab-style cantilever floors, and balanced them atop concrete posts made by pouring concrete into deep holes in the earth. Wright described this structure as holding up a floor in the same way "a waiter would hold a tray on his outstretched fingers."[6]

Wright designed an immense pool of water that greeted anyone approaching the hotel's entrance. The baron who financed the entire operation decided the pool was too costly and unnecessary. Wright asserted himself and sent a message to the baron that if the pool did not remain in the plans he would not stay to complete the project. The

pool was included and Wright remained to complete the building.

Earthquakes were a threat to Japanese wood-framed buildings because the flames from the resulting forest fires would catch onto the structures and cause much destruction. In 1923, following such an earthquake, people lined up in rows and poured buckets of water from the pool onto the wooden parts of the building, saving them from fire.

Both the Imperial Hotel and Fallingwater contain the natural elements of fire, water, and earth. Wright had given the hearth a central place in Fallingwater, and upon entering the Imperial Hotel one is greeted by a large carved mural above the fireplace in the front parlor. Fallingwater, as the name implies, is built directly over a waterfall. At the Imperial Hotel, water played both a functional as well as aesthetic role in the entrance pool. Neither structure towers into the air, even though both were built in the age of the skyscraper; rather, they hug the ground in reverence of nature.

Fallingwater and the Imperial Hotel were built using unusual methods for the time and on unique sites. Wright first sketched the plans for Fallingwater in September of 1935. At this time the owners, Mr. and Mrs. Edgar J. Kaufmann, had no idea that he was going to build their weekend home exactly over the water. They had a cabin in the area for years and probably assumed that he would build it in the same vicinity. Like the Imperial Hotel, Wright took many years contemplating the site of Fallingwater.

> Wright looked at the stream, the falls, the trees, the rock ledges and the boulders. He had written a few years earlier something about what the rock meant to him; 'The rock ledges of a stone quarry are a longing to me. There is a suggestion in the strata and character in the formations. I like to sit and feel it as it is. Often I have thought were great

monumental buildings ever given me to build, I would go to the Grand Canyon of Arizona to ponder them. For in the stony bone-work of the earth the principles that shaped stone as it lies, or as it rises and remains to be sculptured by winds and tides—there sleep forms and styles enough for all the ages for all of man.[7]

Fallingwater seems to flow as the stream meanders around the rocks and hillside on which it is built. It is built in many layers and runs in all directions. As in the Imperial Hotel, Wright sets into drama the play of textures, rough against smooth, as the uniform concrete comes into relation to the jagged stone walls. Inside and out, Fallingwater is full of visual motion, caused by the stair-like shapes that cascade like the waterfall itself. Light also plays an important role as it filters in and around the planes and angles. Fallingwater also employs the use of the cantilever construction style for its slab-like floors. Unlike the Imperial Hotel, some of Fallingwater's walls were built right into the mountainside, and trees were left to come up through the trellis beams. The Imperial Hotel's floor plan is laid out in a symmetrical manner, whereas Fallingwater evolves asymmetrically. The simplicity that Wright observed earlier in the Japanese homes he has included in Fallingwater. The rooms contain just the bare essentials, such as a chair, bookshelf, a dish, and vase of flowers.

Both of these works reflect what Wright meant by organic architecture. He could have built some type of rigid steel-framed structure similar to those in use at the time he built the Imperial Hotel, but instead he chose to use his imagination and work in harmony with nature. He did not have to build the Kaufmann's weekend house directly over the waterfall, but he knew that Mr. Kaufmann loved the site and enjoyed hearing the sound of the waterfall. So, Wright considered, why not build the house where Mr. Kaufmann could hear the waterfall from his living room?

Wright declared that he "would like for each of his houses to look as if it could exist nowhere but in the spot where it stands."[8] He had an innate love for nature, and it was in nature that he found the forms of his architecture. He considered the natural surroundings of each individual site, such as rock formations, trees, and ground. He uses the example of a tree to explain his conception of organic architecture:

> Conceive now that an entire building might grow up out of the soil and yet be free to itself to 'live its own life according to man's nature.' Dignified as a tree in the midst of nature, but a child of the spirit of man. I now propose an ideal for the architecture of the machine age, for the ideal American building. Let it grow up in the image. The tree. But I do not mean to suggest the imitation of a tree.[9]

Wright did not mean that architecture should be built in the form of a tree, but that by using imagination one could work along with nature instead of against it. He did not let the natural limitations of the architectural site bother him; in fact the limitations seemed to be his greatest challenge. He once remarked, "The human race built most nobly when limitations were greatest, and, therefore, when most was required of imagination in order to build at all. Limitations seem to have always been the best friend of architecture."[10] To Wright, the solution to an architectural problem would develop from the nature of the site itself. He would study the problem, and then let his God-given creativeness solve it. This is the process that he used to create both the Imperial Hotel and Fallingwater.

Organic architecture, to Wright, was not merely a style of architecture. Each plan that he designed was unique. Fallingwater and the Imperial Hotel are two distinct styles of architecture, however they are similar in the sense that they were built for their particular surroundings. To Wright, the organic style was a way of seeing nature and

the relationship of people to it; a creative process in which the architect fuses the principles of nature and the materials of people together and comes up with a dwelling that will suit a particular individual and the environment in which the individual is situated.

Chapter 6 Notes

1. Doris Ransohoff, <u>Living Architecture—Frank Lloyd</u> Wright (Encyclopedia Britannica Press, Inc., Chicago, Ill., 1962), 147.
2. Cary James, <u>The Imperial Hotel</u> (Charles Tuttle Co., Japan, 1968), 36.
3. Ransohoff, 88.
4. Olgivanna Lloyd Wright, <u>Frank Lloyd Wright—His Life, His Works, His Words</u>. (Horizon Press, N.Y., 1966), 58.
5. Ransohoff, 88.
6. Ransohoff, 88.
7. Donald Hoffman, <u>Frank Lloyd Wright's Fallingwater, The House and its History</u> (Dover Publications, Inc., N.Y., 1978).
8. Frank Lloyd Wright, <u>The Natural House</u> (Horizon Press, N.Y.), 46.
9. Frank Lloyd Wright, <u>The Natural House</u>, 46.
10. Ibid.

Bibliography

Farr, Finnis. Frank Lloyd Wright. New York: Charles Scribner's Sons, 1961.

Forsee, Aylesa. Frank Lloyd Wright, Rebel in Concrete. Philadelphia: Macrae Smith Co., 1959.

Hoffman, Donald. Frank Lloyd Wright's Fallingwater, The House and Its History. New York: Dover Publications, Inc., 1978.

Jacobs, Herbert. Frank Lloyd Wright—America's Greatest Architect. New York: Harcourt, Brace & World, Inc., 1965.

James, Cary. The Imperial Hotel. Japan: Charles E. Tuttle Co., 1968.

Kaufmann, Edgar, and Ben Raeburn. Frank Lloyd Wright—Writings and Buildings. New York: Meridian Books, Inc., 1960.

Manson, Grant Carpenter. Frank Lloyd Wright to 1910—The First Golden Age. New York: Reinhold Publishing Corp., 1958.

Ransohoff, Doris. Living Architecture—Frank Lloyd Wright. Chicago, Ill.: Encyclopedia Britannica Press, Inc., 1962.

Scully Vincent, Jr. Frank Lloyd Wright. New York: George Braziller, Inc., 1960.

Smith, Norris Kelly Frank Lloyd Wright. New Jersey: Prentice Hall, Inc., 1966.

Szarkowski, John. The Ideas of Louis Sullivan. Minneapolis: University of Minnesota Press, 1965.

Wright, Frank Lloyd. An American Architecture. (Edited by Edgar Kaufmann) New York: Horizon Press, 1955.

_____. An Autobiography. New York: Duell, Sloan, and 1943.

_____. In The Case of Architecture. New York: Architectural Record—McGraw-Hill, 1975.

Wright, Olgivanna Lloyd. Frank Lloyd Wright—His Life, His Works, His Words. New York: Horizon Press, 1966.

Chapter 7

Modern Reductionism: Broadway Boogie Woogie and Hyperprism

Before the Twentieth Century there was, relatively speaking, more of a unity of world view. One author states it in this manner, "Both the actual structure of society and the attitude of men towards society were largely holistic and organismic. Consequently, the pursuits that we now distinguish quite sharply, such as religion, morality, politics, law, science, technology, art, etc., were not formerly regarded or practiced in such a separatist manner."[1] So long as the structure of life was thought to be cohesive, there was little need of the individual exerting one's own rights because the interest of the whole was more important. Beginning with the Renaissance, this cohesive cultural identity began to break down. We live in a specialized society. Many writers are discussing alienation, specialization, and fragmentation. Many modern philosophies and art movements are reductive in nature. Artists have done away with figurative subject matter and reduced the subject matter of art works to combinations of their most basic elements. The process concerned with reducing something down to its simplist attributes has as its basis a concern for eliminating the nonessential. Inherent in the term abstraction is the meaning of removal of certain particular properties and separating them from something else. The Random House Dictionary says, "Also a part of the term abstraction is the art of taking away or separating."[2] Webster's Dictionary also defines abstraction as the "formation of an idea, as of qualities and properties of a

thing, by mental separation from particular instances or material objects."[3] Separation of the discursive element in art from physical objects is one of the reductions that has taken place in art. Many modern artists have rebelled against traditional theories of art which were based on the detailed representation of physical objects seen in reality, such as trees, flowers, and houses. A shift to subject matter that is non-representational has taken place in the Twentieth Century.

It is the purpose of this essay to define reductionism in the context of the work of Piet Mondrian and Edgard Varèse. Piet Mondrian's <u>Broadway Boogie Woogie</u> and Edgar Varèse's <u>Hyperprism</u> will be analyzed and compared with the presupposition that the arts are related and a closer understanding of one art form should help to illuminate the other. The structures of the individual works will be examined for the purpose of understanding the specific types of reduction that have taken place. Similarities and differences in the individual forms of these two specific works will be addressed. Implications based on these findings will be pursued.

Mondrian was an influential member of a Dutch art group by the name of <u>De Stijl</u>. Before he joined the group, he had, already, a career behind him as he was already forty-five in 1917. He had made a name for himself by the end of the nineteenth century as a landscape painter in the style of the Hague school. By 1907 he became interested in the Fauvist style and was also influenced by the pointillistic technique of the Dutch Luminists. By 1910 his interests moved in another direction, the direction of Cubism. During the time Mondrian was in Paris, from 1911 to 1914, his cubist technique developed and he even went beyond the boundaries of Cubism by straightening out curves, eliminating diagonal lines, and created rhythm in his works through the use of straight lines and intersecting angles. He pushed Cubism almost all the way to complete abstraction. Mondrian created a series of compositions in 1917 which were basically black colored sur-

faces on a white background. The first lozenge-shaped paintings, in which the surface is covered with squares or rectangles delineated by black lines and painted with primary colors plus white and grey, start to appear in 1918. By 1920 Mondrian was organizing his color surfaces according to the rules of rhythmic equilibrium based on asymmetry of lines and planes dividing the picture. This embodies the fourth general rule of Neoplasticism: "Constant equilibrium is achieved through the relationship of position and is expressed by the straight line (the limit of the plastic means) in its principal opposition."[4] From 1921 to 1934 greater emphasis was placed on primary colors and a tendency to arrange the picture into large squares with black lines pushed toward the edges. There was a gradual disappearance of the square, and by 1935 one finds compositions consisting of parallel vertical lines which are not intersected and do not define any geometrical shapes. Mondrian moved to New York City on October 3, 1940 and lived there until his death on February 1, 1944. These years are labeled his New York Period. It was during this time that his <u>Broadway Boogie Woogie</u> was produced.[5]

To be able to understand how reductionism was a part of Mondrian's aesthetic theory, it will be useful to our discussion to list the five rules of Neoplasticism outlined by Mondrian as they appeared in the journal entitled <u>De Stijl</u>, which was the primary vehicle for the propagation of the ideals of the group.

The Plastic Means

1. The plastic means must be the plane or the rectangular prism in primary colour (red, blue, yellow) and non-colour (white, black, grey). In architecture, empty space acts as non-colour, and volume acts as colour.
2. The equivalence of the plastic means is necessary. Although differing in dimension and colour, they must nevertheless have the same

value. Equilibrium generally requires a large area of non-colour and a smaller area of colour or volume.

3. The duality of opposition in the plastic means is equally required in the composition.
4. Constant equilibrium is achieved through the relationship of position and is expressed by the straight line (the limit of the plastic means) in its principal opposition.
5. Equilibrium neutralizes and annihilates the plastic means and is achieved through the relationships of proportion in which they are placed and which creates the living rhythm.[6]

An understanding of these laws and their application is hardly derived from a mere reading of them, so their meaning will be further explored through the analysis of them in the context of an essay written by Mondrian entitled <u>Plastic Art and Pure Plastic Art</u>. This was not only an influential work but is also helpful in discovering his viewpoint, because in it he constructs a complete aesthetic theory.

In Part One of this article he redefines the terms objective and subjective as he understands them to apply to art. He says that objective art "aims at the direct creation of universal beauty," and subjective "at the aesthetic expression of oneself, in other words, of that which one thinks and experiences."[7] He goes on to articulate a problem of these opposing elements. In figurative art, a harmony has been produced through a balance between objective and subjective expression. He states that it is the relationships of the forms in the composition that are important. A duality exists in that the forms exist only for the creation of relationships, and that relationships create forms. He says that this problem needs to be solved by the construction of plastic art.

He calls the process or evolution from figurative to non-figurative art a purification process. "Gradually art is purifying its plastic means and thus bringing out the relation-

ships between them."[8] This purification process seems to not only be a philosophy of art but have religious implications as well. His art theory is not divorced from his religious world view. Mondrian grew up with a strict Calvinist background and later turned to Theosophy and religious mysticism.

He continues his thesis by stating that all forms, colors, and lines represent figures, and that no forms are completely neutral; however, geometrical forms are so profound an abstraction that they are considered neutral. In this process of purification from figurative art, if pure forms are used, they set up pure relationships between one another. There is a process or evolution away from figurative art to pure plastic art which communicates on a higher level. There are certain laws of the plastic arts that are fixed and must be realized. Mondrian says, "There are fixed laws which govern and point to the use of the constructive elements of the composition and of the inherent relationships between them."[9] These laws he outlined in his five laws of Neoplasticism.

In Part Two of his essay he relates his theory of Neoplasticism by analogy to new scientific findings and particularly the laws of health. He states that in the same way that our health is related to the food that we eat, the success of an art work depends on the use of the constructive elements that are used. A unity is important to life between the physical and spiritual realms, and also, a unity in art is important. He talks about achieving a dynamic equilibrium which is opposed to the static equilibrium of the conventional artistic laws. This equilibrium is not without movement; in fact, he speaks of it being in constant movement. Further, he states that rectangular relationships are the most appropriate for the destruction of static equilibrium. He discusses the law of the denaturalization of matter in which the representation of the natural color is to be avoided. The more pure the color, the better, i.e., the primary colors are best for the denatural-

ization of matter. This is in accordance to his rule number one of Neoplasticism.

Mondrian denounces both Surrealism and Cubism. Surrealism, he says, was based on a literary movement, and since it is descriptive in nature, it must be figurative. However purified Surrealism may be, according to Mondrian, it is opposed to pure plastics because it is not purely abstract. Much of the content of Surrealist works deals with dream-like subject matter. Mondrian says, "So long as it remains in the realm of dreams, which are only a rearrangement of the events of life, it cannot touch true reality."[10] Mondrian is advocating a complete break with figurative art. He argues that since Cubism is half naturalistic and half abstract, it has not been completely purified yet. He concludes with the theory that by the unification of sculpture, painting, and architecture a new plastic culture would someday be created, and that art would cease to be separated from the surrounding environment, and we would eventually live in a cohesive plastic unity. Essentially, this utopian outlook ignores other forces in society and limits one's vision to an idealistic dream for the future of art and mankind.

Edgard Varèse was born in Paris and received his musical training there. His early works were influenced to some degree by Debussy and Richard Strauss. He preferred a wide company of friends. It was a little book by Ferrucio Busoni entitled <u>Sketch of a New Esthetic of Music</u> that encouraged him in his attempts to free music from anyone else's rules but those rules set by the composer himself. After 1916 Varèse moved to the United States and preferred the company of the Alfred Stieglitz's Photo-Secession group called "291"; however, again he associated with a large range of individuals. By the late 1910's Varèse was an established composer with at least nine works to his credit.[11]

Edgard Varèse's aesthetic viewpoints are not easily assessable. He did not believe that art should be analyzed; therefore, he did not write much about his works or his

philosophy. He was eclectic in nature when it came to the absorption of ideas from different sources. Two major art movements at the time that influenced him were Cubism and Futurism. This, however, does not mean that he took the theories of these groups wholesale and applied them to his work. However, traces of these influences can be found in his works.

Painting is usually thought of as a space art and music as a time art; however, this distinction was being challenged in the twentieth century. Cubist artists tried to show varying planes of objects that are not normally seen at one time. For instance, Picasso would show three different views of a woman's face simultaneously. In doing so, he not only broke up her face into flat planes, but also dealt with three differing time aspects. One of the aspects of Cubism that is important to consider in relation to the work of Varèse is space-time thinking. Varèse himself said that he was interested in creating planes of space in his work. Varèse also considered music in terms of time and space. He spoke of his music as "spatial—as bodies of intelligent sounds moving freely in space."[12] He created angular sound planes and masses that can be related to Cubism in painting.

Spatial thinking was also a key factor in the thinking of the Futurists. Their writings are full of references to volumes, masses, and planes. The Futurists felt that Cubism was too cold, intellectual, and motionless. The Futurists wanted to portray motion in their work. Varèse did not claim to hold to the aesthetic beliefs of the Futurists. In fact, he was against the concept of using just noises from machines. There is much talk concerning whether he was influenced more by Cubism or Futurism or other philosophies. It is more important to analyze a specific piece, in this case Hyperprism, to isolate its unique form so that one understands the structure of one work rather than to generalize about many.

Broadway Boogie Woogie and Hyperprism will be analyzed for their intrinsic qualities and how these qualities

determine the underlying structure of the works. Broadway Boogie Woogie will be analyzed for the specific elements of space, color, rhythm, texture, and line, and their attributes will be considered for the purpose of determining the significant expressions of the work. These attributes will in turn be compared with similar musical elements of space, timbre, rhythm, texture, and dynamics in Edgard Varèse's Hyperprism for the purpose of determining any purposeful relationships that may exist between the two works. The results derived from the intrinsic analyses will be used as evidence for the support of the final conclusions regarding the nature of reduction that has taken place in each work.

Broadway Boogie Woogie was painted from 1942-1943 and is oil on canvas. It measures 127 x 127 cm., is signed PM in the lower left-hand corner, and dated in the lower right-hand corner 42/43. It was given as a gift by the artist to the Museum of Modern Art via the Valentine Dudensing Gallery, New York in 1943.[13]

Broadway Boogie Woogie is painted on a large square canvas. The spatial relationships are relatively flat; however, a certain depth is created by the juxtaposition of smaller and larger size relationships and the visual color dynamics employed. The larger white and yellow rectangles tend to recede into the background while the darker reds and blues tend to pierce the canvas and project forward in space. Depth is reduced by painting flatly on the surface of the canvas and not using the techniques of one-point perspective, overlapping, or aerial perspective. The large white rectangular shapes create areas of void, which are not visually active. Shapes are used to help create balance in the work. The painting is composed in an asymmetrical pattern of shapes. The large rectangular shapes are distributed unequally throughout the work. The smallest square shapes are also distributed randomly along the yellow bands that criss-cross the surface. The large white shapes are stable compared to the fluctuating shapes, textures, and colors that surround them. One feels a sense of

the resulting spatial balance. This is what Mondrian would call dynamic equilibrium.

The surface structure is one of diagonal and vertical lines sprinkled with blue, red, and yellow, square, confetti-like dots at irregular intervals. Mondrian has reduced the elements of painting down to basically primary colors with the addition of yellow and grey which is in harmony with his first principle of Neoplasticism: "The plastic means must be the plane or rectangular prism in primary colour (red, blue, yellow) and non-colour (white, black, grey.)"[14] These colors appear to be painted right from the tube, pure and unmixed. Yellow seems to predominate the overall painting and gives it a very electrifying mood. The large white areas add stability to the painting while the small colored squares seem to be in constant vibrating motion. The intensity of the colors, which are pure and bright, create a mood of tension and anxiety. Color tonality can either be pleasing to the eye or stimulating. In this painting the colors are not blended and subtle in nature, but bright and flashy like a neon sign. The resulting sensation is one of fluttering pulsations.

Broadway Boogie Woogie is a flat painting, and yet it dances with rhythm. This rhythm is created through repetition. There is repetition of horizontal and vertical bands, repetition of the colors throughout the composition, and repetition of rectangular shapes and the placement of smaller rectangles or squares at or near the center of larger rectangles, which are also distributed randomly. The steady rhythmic pulse of the small dots is played against the larger rhythmic variations. A rapid vibrating rhythm is created by the small rectangular dots that are placed in a gridlike pattern. If one called the space between bands measures, there would be seven measures horizontally and ten measures vertically. Within these measures there is varied rhythmic activity. Movement and stasis are present at once and are a part of the dynamic equilibrium of the piece. Push-pull dynamics and oscillating colored lines and shapes created a bouncing staccato rhythm through-

out the work. This movement is reminiscent of the pulsating geometry of the urban vehicular traffic networks of the city of New York, or it may be likened to the Boogie Woogie dance itself. Mondrian has definitely created the constant movement and living rhythm that he spoke of in his theory of Neoplasticism.

The actual texture of the surface of the picture plane is smooth; however, there is an invented visual texture that is created by the combination of linear, spatial, and color relationships that create a variegated visual texture. This texture could actually be termed rough as it emits an uneasy and restless quality.

The use of texture also regulates the dominance of the subject material, in this case, the sections of the surface. Invented texture, created by the use of a dot pattern throughout certain areas, lends to the excitement of that area in contrast to the plainness of the flat white areas. Mondrian controls the dominance of an area by the use of texture.

The texture employed is also a hard-edge texture which adds to the rigidity of the forms. This type of texture does not communicate a feeling of warmth, but of coldness, harshness, and distance.

The line quality of the work is created by narrow bands of color that are painted on a white background. Lines have the quality of direction to them and can be zigzagged, curved, vertical, or horizontal. There is an absence of curved lines in Mondrian's painting. Mondrian has reduced the direction of the lines to vertical and horizontal. Straight lines may evoke a stable, even restful quality to a work; however, it depends on how they are arranged. These horizontal and vertical lines intersect at right angles forming many rectangular shapes that divide the picture plane. The lines that are employed are angular and repetitious. The mind also creates strong diagonals running from corner to corner of the various rectangles. The complexity and variety of lines in this work create energetic patterns that communicate a restless, nervous energy.

Hyperprism is organized, on the largest scale, into planes or blocks of space. There is a balance of the proportional structure of the piece which is achieved through the balancing of the sections. There is a relationship between the sections that is achieved by the striking use of contrast, resulting in abrupt breaks. These cadences contribute to the block-like quality of the individual sections. An example may be seen in the opening measures of the work. In measure 1, a loud attack by the cymbals, tam-tam, and bass drum generate a mass of sound. These are joined by the crescendo of the lion's roar and the rattles. Against this background, pitched material starts in measure 2 with the tenor trombone stating a sustained C#; this is joined by the bass trombone playing a D pitch in measure 5. The resultant spatial form in the first twelve measures is one of alternating planes of sound.

The trombone and horn sound mass is a constantly fluctuating entity, swelling and decreasing in volume, subtly shifting tone color which is punctuated by varying durations of the individual tones and the silences surrounding them. Percussion begins the piece, and both the combinations of instruments in use, and the rhythms, are in constant flux throughout the work to measure 11. Near the end of the passage, starting in measure 10, there is a climactic effect created by the greater number of instruments employed than have been heard up to this point. Starting in measure 24, and from this point to the end of the piece, larger intervals and larger blocks of spatial manipulations take over. There is a large section of silence in the percussion sections in measures 85-88. Their combination and interaction result in a definite sense of spatial projection. A three-dimensional geometrical pattern of shapes is certainly implied.

The piece ends with tam-tams, cymbal, and metallic percussion. It is this effect that creates a sectional articulation. Hyperprism is organized according to the recurrence of large sections of sound. Hyperprism is a very short work, only four minutes in duration. It is very com-

pact; within this context, by the use of planes and masses, there is a filling of the vertical space. Hyperprism is asymmetrically organized according to the recurrence of large sections which establish a strong sense of unity and cohesiveness in the work. These angular spaces add qualities of abruptness and harshness to the work.

Hyperprism was composed for pitch and non-pitch instruments consisting of ten wind and brass against seventeen percussion instruments including a string drum or lion roar and a siren. In Hyperprism the wind and brass are treated in groups according to timbre and range; piccolo, flute, clarinet, horns, trumpets, and trombones each form a block of intensity and contribute a particular tone or color. The percussion instruments are grouped into categories of metal, wood, shaken instruments, etc., which are often mixed, but at times are treated as a group. These percussion instruments represent in their diversity a wide range of sound possibilities from which Varèse was able to draw. In general, the percussion function either independently or in a supporting role to the wind and the brass. A number of coloristic elements is presented in the percussion which recur in varied forms throughout the piece. The metallic nature of the percussion adds a sense of machine-gun quality to the composition, as if he were trying to imitate some of the sounds that force themselves upon one who works in an industrial setting.

Measures 6 and 7 in the percussion, which constitute a rhythmic tone color, are immediately repeated in measures 8 and 9. They recur at measures 24 and 25, and again in measures 65-66 and 67-68. The pattern of a quarter note followed by a dotted quarter note, three quarter notes, and then a half note in measures 6 and 8 is altered to a quarter note, dotted quarter note, and half note pattern in measure 24; then it is changed to a three-quarter note and half note pattern in measure 65 and a quarter note, dotted quarter note, three-quarter note, half note pattern in measure 67. This could be considered as a kind of isorhythmic design. In the medieval isorhythmic motets, the melody,

called the color, was taken as a series of pitches without rhythm and without necessity for repetition of a specific melodic shape. To this series of pitches the composer then applied a specific rhythmic pattern, the talea or "cutting," which had the effect of cutting up the melodic material. To this pattern, or talea, the original pitch sequence or color was fitted so that the final product was a combination of the two elements, both being repeated. The taleas in Hyperprism are set against a continually changing color in the manipulation of the masses and planes around them. These colors punctuate the piece and pierce the air, adding a feeling of restlessness and uneasiness.

The horns become more and more active rhythmically with each successive entrance until there is a greater outburst of the trombone in measures 7-8. From the upbeat to measure 5 onward, the bass trombone, even though it is intermittent, creates a definite plane of sound. This pitch influences events at measure 12. The top pitch in the pattern becomes C, which is the same distance below C# as D is above it. The upbeat to measure 15 contains new pitch material as the horns enter with a D-F#-B♭ configuration. The crescendo in measure 16 is preceded by a clearly recognizable reference to the percussion in the opening measures: cymbals, tam-tram, and bass drum in a triplet pattern, the same series that served as upbeat to measure one. This reference to earlier material is significant. It creates a rhythmic delineation of space. Areas of rhythmic complexity in the percussion do not, as a rule, coincide with similar areas in other instruments. More often, such areas are used to balance sustained masses of sound. An example of this occurs in measure 10. The rhythm of the percussion chords is set against the sustained C# in the horn. The activity of the percussion relative to both tone color and rhythmic quality, is in contrast to the relatively static tone in the horn. In measure 19 the rhythmic activity is of a similar nature. but set against the high C flute harmonic. Rhythm in Hyperprism adds unity to the work by balancing the silent areas.

There is a total lack of percussion in measures 39-48 creating a block of silence in the percussion section as a background for the polyphony of the pitched instruments starting in measure 41. In the trombone section there is a repetition of an interval of a third, starting with an A in the bass and a C# in the tenor. The bass moves to a G; however, immediately the bass then moves to a C and the tenor to an A, creating A as the lower boundary. G♭ is superseded as an upper boundary in the trumpet section by an E. Measures 41-59 are the central area of textural complexity for the wind and the brass; however, the percussion appear only during moments of sustained tone, or during silences. This middle section formulates rhythmic groupings by means of effective placement of silences and percussion intrusion. The texture alternates between rough, jagged sections of percussion, brass, or woodwinds, alternating with sections of relative silence, which evokes a smooth texture.

Increasing dynamic intensity is a factor that changes throughout the work. A new section begins at measure 59 which is characterized by projection of large spans and the extension of forms. In measure 62 the trombone is reasserted as a solo instrument. The percussion section of measures 59-67 is highly active. It remains active even when the trombone moves rapidly through pitch changes in measures 65-67. There is a coordination between pitched and unpitched sounds as the trombone becomes a solo instrument at measure 63. The instrumentation and the character of what is being played change in the percussion. The sustained rolls, indicated by the "laissez vibrer" notations for the sirens and metallic instruments, are also reflected in the held notes in the horns and trombone in measures 59-62. The percussion for measures 6871 is confined to Chinese blocks which emphasizes the sound of the woodwinds at this point. The blocks prefigure the quick rhythms of the woodwind figures. The percussion gradually gains in momentum as the pitch change ends in the woodwinds. Intensification by means of quick notes,

crescendo, and finally the crash cymbal propels the piece forward until it reaches maximum loudness.

It is evident from the intrinsic analyses that both Mondrian and Varèse break up their compositional spaces into planes that are balanced asymmetrically. Mondrian creates a dynamic relationship between the large white spaces in Broadway Boogie Woogie and the surrounding colors, shapes, and textures. The large white spaces could be related to the silences in Hyperprism. They both serve the same purposes. They act as buffer zones to contrast and balance the accompanying material.

Mondrian, in Broadway Boogie Woogie, creates a balance between larger and smaller rectangular and square shapes to create a dynamic equilibrium. Varèse, in Hyperprism, balances the spaces by contrasting blocks of silence with rhythmic, dynamic, and timbral interludes emitting an overall feeling of unity, balance, and cohesiveness.

The planes in Broadway Boogie Woogie alternate between large and small shapes, but they are always angular and sharp, evoking a feeling of machine-like coldness, rather than warmth and humanness that would be expressed through the use of curved shapes. Similarly, Varèse creates aural planes by contrasting timbral, dynamic, and rhythmic elements with sections of silence in Hyperprism. These planes also sound hard-edged and machined. Both works evoke a similar feeling of angularity, abruptness, and even harshness.

Mondrian uses the color yellow as a predominant color in Broadway Boogie Woogie to evoke a lively mood. Varèse uses sirens, cymbals, and tam-tams to create a color that resembles machine-like sounds. Varèse wants to arrest the attention of the listener through aural attacks. Then he calms one with less active sections and juxtaposes these areas with blocks of silence.

The color in Broadway Boogie Woogie is constantly vibrating because of the use of repetition at various intervals. Varèse combines traditional orchestral instruments with sirens, lions' roars, laughing, etc., to create piercing,

restless, uneasy contrasts in timbre. Varèse uses repetition of silences, rhythmic motifs, and talea patterns in <u>Hyperprism</u> to create push-pull patterns that are similar to the pulsating visual color dynamics in Mondrian's painting.

There is a rapid, vibrating rhythm in Mondrian's work created by the pulsation of the small variegated dots. Mondrian also uses the larger stable planes in <u>Broadway Boogie Woogie</u> to create a balance between them and the quick, rhythmic passages of color. Varèse similarly uses short, rhythmic passages to balance large, silent blocks. Varèse uses rhythm for the purpose of delineating space and to sustain balance between masses of sounds. There is no regular succession of beats or accents in <u>Hyperprism</u>, although Varèse does restate material on occasion; but it is very rarely restated in exactly the same manner. Rhythm in <u>Hyperprism</u> is characterized by constant changes in asymmetrical blocks of sound patterns.

Webster's Dictionary defines texture in an artistic composition as "The structure or structural quality resulting from the artist's blending of elements such as parts in music, the pigments and brushwork in painting, etc."[15] Keeping this definition in mind, Mondrian eliminates rough actual textures from <u>Broadway Boogie Woogie</u>, as brush strokes are not allowed to be apparent, and only smooth surfaces prevail, but the invented visual texture that is created as a result of the mixture of spatial and color relationships is variegated, giving one a feeling of roughness, sharpness, and jaggedness. Varèse creates sounds that seem to be created by machinery by employing several methods, such as his choice of instruments and their groupings, which produce unique timbres. The sounds are often produced at loud dynamic levels. Texturally, he blends sounds that seem to be polished, smooth, shiny, and sleek with sounds that seem ragged, jagged, and full of friction. There is a similarity between the juxtaposition of differing visual textures in <u>Broadway Boogie Woogie</u> and the aural textures of <u>Hyperprism</u>.

Line can refer to the outline of the forms in the painting as well as the individual lines crisscrossing the surface of the picture plane. Lines in the Mondrian painting are used to delineate forms, forming rectangular shapes. These lines form a grid-like pattern which pulsates and transmits an energetic, bouncing, nervous, restless mood.

The term "line" may be transferred to music in the sense of outlining sound masses, melodies, and sections. There are similar functions to the use of line in the Mondrian painting and the use of dynamics in Hyperprism. The rapidly varying dynamics between soft and loud, between the clanging of cymbals, the beating of drums, and playing of trombones, trumpets, and strings, etc., delineate the form of Hyperprism which is made up of rectangular shapes or blocks of sound formed into asymmetrically balanced patterns. These sharp-edged, angular, non-blending sound masses in Hyperprism can be likened to the clearly delineated, non-blending rectangular shapes in Broadway Boogie Woogie and evoke a similar restless, energetic, aural sensation.

Based on the formal analyses of both art works, several conclusions, relating to the specific nature of reduction that has taken place in the respective works, may be drawn. Although both Mondrian and Varèse use principles of reduction in their respective works, the specific elements that are reduced are different and the degree to which they are reduced also differs. Mondrian reduces painting down to flat planes, where Varèse employs blocks and planes of sound. Mondrian, moving away from Cubism, has eliminated blocks or cubes from his work completely. Both artists have eliminated representation. Varèse is not trying to represent any particular kind of machine with his music . Mondrian is not trying to represent a block of New York City from the sky simulating what the traffic patterns may have looked like; he is capturing a sense of rhythm and balance in his work that is being worked out in "purely plastic means." Both works were influenced by machineage technology of the Twentieth

Century as both works of art convey machine-like characteristics such as angularity, abruptness, and a mood of tension.

Although the similarities in the works of Mondrian and Varèse have been stressed, this does not mean that they have exactly the same attributes portrayed in different media. Both similarities and differences exist in the nature of the reductions. Color is diminished to red, yellow, blue, white, and grey in Mondrian's painting. Varèse eliminates tonality in the Classical sense. No such things as chord progressions, based on a root, modulations in a tonal sense, or counterpoint based on dissonance being resolved by pitch relationships, exist in Varèse's work. The common factor involved is that each artist combines the particular elements of his respective discipline to form similar planes of action operative in his specific work.

Mondrian reduces figures into flat planes. There is a conspicuous lack of curvilinear shapes. Shapes are reduced to the square and rectangle. There is a very shallow sense of depth in Mondrian's painting due to the lack of spatial devices such as overlapping, sfumato, and linear perspective. Varèse, on the contrary, creates blocks of aural space, by the overlapping of planes of sound and silence, to create masses of form which give the illusion of vast depths of space and sound.

Chapter 7 Notes

1. Philip P. Wiener, ed. <u>Dictionary of the History of Ideas</u> Vol. 1 (N.Y.: Charles Scribner's Sons, 1973) 108.
2. Lawrence Urdang, ed. <u>The Random House Dictionary of the English Language: College Edition</u> (N.Y.: Random House, 1969) 6.
3. David B. Gurlink, ed. <u>Webster's New World Dictionary of the American Language</u> (N.Y.: The World Publishing Co., 1968) 6.
4. Hans L.C. Jaffé, <u>De Stijl</u> (N.Y.: Harry N. Abrams) 226.
5. L.J.F. Wijsenbeek, <u>Piet Mondrian</u> (New York Graphic Society, Ltd, 1968) 145.
6. Jaffé, 226.
7. Robert L. Herbert, ed. <u>Modern Artists on Art</u> (Mondrian: Plastic Art & Pure Plastic Art) N.J.: Prentice-Hall, Inc., 1964) 115.
8. Herbert (Mondrian) 116.
9. Ibid., 119
10. Ibid., 125.
11. Jonathan W. Bernard, <u>The Music of Edgard Varèse</u> (Yale University Press, 1987) 1.
12. Ibid., 7.
13. <u>The Solomon R. Guggenhiem Museum: Centennial Exhibition: Piet Mondrian</u>, 1971, 212.
14. Jaffé, 226.
15. Gurlink (Webster's) 1472.

Bibliography

Bernard, Jonathan W. The Music of Edgard Varèse. Yale University Press, 1987.

Busoni, Ferruccio. Three Classics in the Aesthetics of Music. (Sketch of a New Esthetic of Music) New York: Dover Publications, Inc., 1927.

Champa, Kermit Swiler. Mondrian Studies. Chicago: Chicago University Press, 1985.

Chandler, Arthur. The Aesthetics of Piet Mondrian. New York: MSS Information Corp., 1972.

Chip, Hershel B. Theories of Modern Art: A Source Book by Artists and Critics. University of California Press, 1968.

Clark, Charles Lynn. Mondrian and De Stijl. Serge Lemoine. Trans. New York: Universe Books, 1987.

Copland, Aaron. The New Music: 1900-1960. New York: W.W. Norton & Co., 1968.

Francina, Francis and Charles Harrison, eds. Modern Art and Modernism: A Critical Anthology. New York: Harper & Row.

Gibbons, Irene. Piet Mondrian. L.J.F. Wijsenbeek. Trans. New York: New York Graphic Society, Ltd., 1968.

Herbert, Robert L., ed. Modern Artists on Art: Ten Unabridged Essays. New Jersey: Prentice-Hall, Inc., 1964.

Holtzman, Harry. Introduction, Mondrian. By Pieter Cornelius. New York: The Pace Gallery, 1970.

Holtzman, Harry and Martin S. James. Trans. The New Art—The New Life: The Collected Writings of Piet Mondrian. Boston: G.K. Hall & Co., 1986.

Jaffé, Hans L.C. De Stijl. New York: Harry N. Abrams, Inc. _____. Piet Mondrian. New York: Harry N. Abrams, Inc.

Jolivet, Hilda. Varèse. Hachette Literature, 1973.

Lambert, Jean-Clarence. Abstract Painting. London: Heron Books, 1970.

Lewis, David. Introduction & Notes, Mondrian 1872-1944: The Faber Gallery. New York: Faber & Faber.

Mondrian: Drawings, Watercolours, New York Paintings. The Baltimore Museum of Art, 1981.

Ouellette, Fernand. Trans. <u>Edgard Varèse</u>. By Derek Coltman. New York: Da Capo Press, 1981.

<u>Piet Mondrian 1872-1944: Centennial Edition</u>. New York: The Solomon R. Guggenhiem Museum, 1971.

Seufor, Michel. <u>Piet Mondrian: Life and Work</u>. New York: Harry N. Abrams, Inc.

Stangos, Nikos, ed. <u>Concepts of Modern Art</u>. New York: Harper & Row., 1974.

Tomassoni, Italo. <u>Mondrian</u>. The Hamlyn Publishing Group, 1969.

Varèse, Louise. <u>Varèse: A Looking-Glass Diary</u>. Vol. 1: 1883-1929. New York: W.W. Norton & Co., Inc., 1972.

Whitworth Art Gallery. <u>Mondrian and the Hague School</u>. University of Manchester, 1980.

Dissertations

Bloch, David Reed. "The Music of Edgard Varèse." Diss. University of Washington, 1973.

Johnson, Charles. "A Comparative Study of the Views of Present Reality Manifested in the Art Works of Fernand Leger and Edgard Varèse." Diss. Ohio University, 1970.

Articles

Cage, Joan. "Edgard Varèse in Silence." Cambridge Mass.: The MIT Press, 1966, pp. 83-84.

Chou, Wen-Chung. "Varèse: A Sketch of the Man and His Music." Musical Quarterly LII, 2 (April 1966), pp. 151-170.

"De Stijl: 1917-1931, Visions of Utopia." Art Journal Vol. 42, Fall 1982, pp. 242-246.

Maiorino, Gioncarlo. "The Legend of Geometry Fulfilled: Abstraction and Denaturalization of Pattern. The Paintings of Piero Della Francesca and Piet Mondrian." Gazette Des Beaux-Arts Ser 6 V 107: 111-17, Mr. '86.

"The De Stijl Artists." The Structuralist 25/26:72 '85-'86.